Treasures of THE UFFIZI

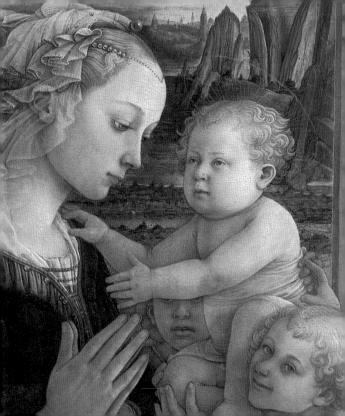

Treasures of THE UFFIZI

A TINY FOLIO™ Abbeville Press Publishers New York London Paris Front cover: Detail of Sandro Botticelli, The Birth of Venus, c. 1480.

See page 90.

Back cover: Michelangelo Buonarroti, The Holy Family (The Doni Tondo), 1504. See page 123.

Spine: Detail of Piero della Francesca, The Duchess of Urbino, 1465-70.

See page 62.

Frontispiece: Detail of Fra Filippo Lippi, Madonna and Child with Two Angels, c. 1464. See page 58.

Page 6: Detail of Giuseppe Zocchi (1711-1767), View of the Uffizi, n.d. Page 14: Detail of Artemisia Gentileschi, Judith and Holofernes, c. 1620.

See page 215.

Page 80: Detail of Sandro Botticelli, Primavera, 1477-80. See page 88. Page 91: Detail of Sandro Botticelli, The Birth of Venus, c. 1480. See page 90.

Page 242: Detail of Rachel Ruysch, Flowers and Insects, 1711. See page 257.

Page 200: Detail of School of Fontainebleau, Gabrielle d'Estrées with a Sister, c. 1590. See page 294.

Page 304: Detail of El Greco, Saints John the Evangelist and Francis, c. 1600. See page 307.

For copyright and Cataloging-in-Publication Data, see page 319.

CONTENTS

Introduction	7
Italian Painting	15
Dutch, Flemish, and German Painting	243
French and Swiss Painting	291
Spanish Painting	305
Index of Illustrations	313

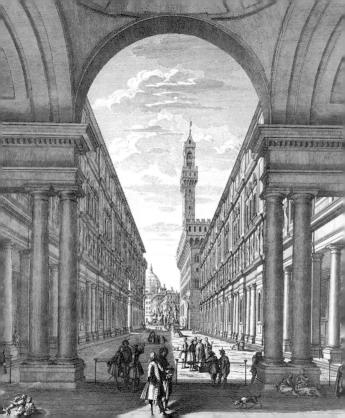

INTRODUCTION

In this volume are reproduced the best paintings from the Uffizi Gallery, among them the most famous works of the Italian Renaissance, which made Florence and Tuscany famous throughout the world. The history of the Uffizi reflects its close relationship with the city of Florence.

The Uffizi was the first European museum assembled to serve purposes that were not only-or at least not essentially-private. When the original nucleus of the collection took form, the great palace that was to house it and eventually give it its name already existed. Cosimo I de' Medici (1519-1574), who became grand duke of Tuscany in 1569, had the palace built by Giorgio Vasari (1511-1574). It was originally made to house the administrative offices (uffizi) of the new grand duchy, for Cosimo, whose family dynasty was to rule in Tuscany until 1737, wanted to build his state upon a solid bureaucratic foundation. The new centralized form of the Florentine government was physically demonstrated by the Uffizi's connection on one side, by way of a bridge, to the Palazzo Vecchio, ancient seat of the city government, and on the other side, by way of a long passageway (known as the Vasari Corridor), to the Pitti, the grand ducal palace.

An elegant if severely official structure, the Uffizi wraps like a horseshoe around its courtyard and stands

between the Arno River and the Piazza della Signoria, or civic square. On the ground floor is an open portico with large carved doors leading to various offices. Above this portico rise two more stories, set off by projecting cornices, and finally what was once a roofed open gallery, a feature typical of ancient Florentine residences. From the beginning, the Medicis used this top floor for entertainment more than for bureaucratic functions. The airy gallery offers extraordinary views: to the south, the Arno and hills dominated by the Pitti Palace, the Fortezza del Belvedere, and the church of San Miniato al Monte; to the north, the piazza with views of the tower of the Palazzo Vecchio and the dome of Santa Maria del Fiore.

The idea of pairing Medici's superb art with these stunning views of nature and city life was stimulating and innovative, but it fell to another ruler and another architect to carry it out: Francesco (1541–1587), Cosimo's son, who assembled a refined collection; and Bernardo Buontalenti (1536–1608), a versatile Mannerist and a brilliant technician capable of giving shape to his patron's fantasies.

Their collaboration resulted in the nucleus of the future gallery in the great octagonal room called the Tribune and in the rooms off the east side of the palace's fourth floor. From 1590 the objects and works of art on display were listed in inventories, and these pages, together with early seventeenth-century descriptions and documentary images, such as the famous view of 1775

by Johann Zoffany (now in the English royal collections), offer a sense of the original appearance of these first museum rooms. The corridors were lined with ancient sculptures from the Roman period that still form one of the museum's most important collections.

The display included a variety of objects, in accordance with the eclectic taste popular at the time: not only paintings and sculpture, but also coins, medallions, small bronzes and pieces in precious stone, natural curiosities, scientific instruments, and weapons. Some rooms were dedicated to a single collection, and the ceilings of such rooms carried frescoes related to the objects on display.

Among the rooms, the Tribune was the museum's real jewel. (Sadly, its contemporary appearance offers only a glimpse of the dazzling splendor of its original arrangement, which was destroyed during the rule of the Lorraines in the eighteenth century.) The decoration of this room had a complex cosmological meaning: the design of the marble floors was an allusion to earth; the red fabric covering the walls alluded to fire; the octagonal vault was inlaid with mother-of-pearl and crowned by a wind rose, emblems of water and air. Medici symbols were scattered throughout the decoration, indicating that the ruling dynasty, responsible for the room's imposing collection of artistic and natural wonders, was prominent in the cosmic order. The walls were hung with paintings, and a shelf ran around the room at eye level

bearing statuettes and small cases full of treasures. In the center of the room, like a miniature reproduction of the Tribune itself, stood an octagonal cabinet inlaid with precious stones; such inlay was typical of the grand ducal workshops, which were located in the west wing of the Uffizi. Over time, unique ancient sculptures from the Medici collection—including the Venus de Medici, the Wrestlers, and the Knife-Grinder—were added to the room and can still be seen there

In the Tribune and adjacent rooms the Medici princes entertained illustrious allies and guests, ambassadors and sovereigns, showing off not only their refined taste but also the family's wealth and power. These rooms have since seen dramatic events tied to successive ruling dynasties followed by the unified Italian state and to changes in taste and in standards of display. Throughout this long process, the Medici acted as catalysts, for all the grand dukes saw the gallery as the pride of the family collections, and each labored to expand and embellish its rooms, which gradually took over the entire fourth floor (except for a large area to the east, where Buontalenti had built a theater for Francesco). The collections grew to include miniatures, portraits, Etruscan relics, tapestries, ceramics, and bronzes; and the painting collection was constantly enlarged. The travels and intermarriages that linked the Medici to other courts of Italy and Europe greatly increased the family's opportunities for cultural exchange and enrichment. Even when the family's political position weakened, the descendants of Cosimo I were still able to procure the best European art through shrewd agents and far-flung connections, and they still had the wealth that permitted each family member—whether cardinal or duchess—to have his or her own court, palaces, villas, and favorite artists.

With foresight and generosity, the last Medici, Anna Maria Luisa (widow of the Elector Johann Wilhelm), drew up a family pact in 1737 binding the collections forever to the Uffizi and to Florence, thus avoiding the dispersion of a patrimony that had long since ceased to be "private" in any sense.

Subsequent acquisitions were made to update the collection or to include examples from periods or territories less well represented. These were only faint echoes of the splendors the Medici had amassed, for the family had followed the highest criteria and made sure choices in their purchases and commissions. Additions to the collection have been infrequent; recent ones include prestigious government acquisitions (two Goyas and an El Greco) and private donations that have filled out the antique self-portrait collection. (Also noteworthy are works that entered the museum with the Contini Bonacossi donation and the Siviero collection.)

The Lorraines, in keeping with the rationalism of the eighteenth century, reorganized the museum displays

and reworked several rooms in a refined Neoclassical style, but they also removed collections not related to painting and ancient sculpture: some of these (weapons, silver) were dispersed, while other homogeneous groups went to form the bases of important Florentine museums, such as the Museum of Science and the Specola Museum of Natural History.

Thanks to the public character conferred on the Uffizi by the last Medici, the museum survived almost unscathed the confiscations of the Napoleonic period and the thefts of World War II. Today the Gallery displays ancient sculpture along the grand staircases and in the corridors and has forty-five rooms dedicated to painting from the thirteenth to the nineteenth century. These works are divided by school, according to the reorganization done after World War II. Other pieces are displayed in the Vasari Corridor, an area that is unfortunately not always open to the public. On the third floor of the building, in what was once the foyer of Francesco's now-destroyed theater, is the collection of drawings and prints. One of the most important of its kind in the world, the collection contains some 110,000 sheets. The building also houses the world's most important collection of self-portraits, started by Cardinal Leopoldo de' Medici and augmented in 1981, on the occasion of the 400th anniversary of the Uffizi, with a gift of 200 selfportraits donated by famous contemporary artists.

The paintings that appear in this book, and the other works currently on display, are of major importance; many pieces of comparable quality are in storage or are being temporarily held elsewhere. More than fifty paintings, and some statues, damaged by the bomb that exploded outside the walls of the Uffizi in May 1993 are to be restored; only three paintings, including Bartolomeo Manfredi's Concert (page 211) and Gerrit van Honthorst's Adoration of the Shepherds, were damaged beyond repair. Recent changes are promising: the two lower floors of the building, which had been occupied by the State Archives since approximately 1850, have been cleared, and the museum will soon expand throughout the building. This reorganization will involve not dramatic architectural changes, but rather a thorough restoration of the original Vasari rooms and redistribution of the displays to bring them into accordance with contemporary ideas about museum exhibition

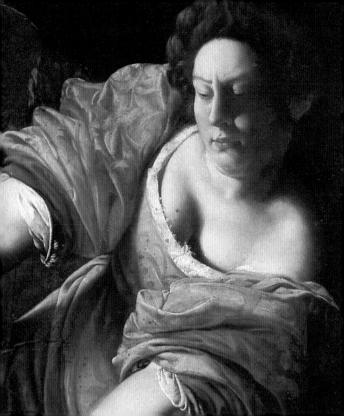

ITALIAN PAINTING

The oldest paintings on display in the Uffizi are Tuscan works of the thirteenth and fourteenth centuries. Some of these works still echo the Byzantine tradition; others show the early effects of the humanization of painting, which led artists to experiment with new techniques for examining and representing nature. Fundamental texts for subsequent Western art, the paintings of the Madonna and Child by Cimabue, Duccio di Buoninsegna, and Giotto (pages 28–30) were all originally altarpieces in Florentine churches, where they offered divine images that were newly accessible because they were endowed with more recognizable human bodies and emotions.

Later generations, in both Florence and Siena, followed in the wake of these three leaders. In Simone Martini's famous *Annunciation* (page 36), the extraordinary use of gold and the gestures of the main characters create a courtly and aristocratic scene of humanity. The brothers Pietro and Ambrogio Lorenzetti were deeply influenced by the artistic environment of Florence; their different pictorial languages can be examined by comparing Ambrogio's *Presentation in the Temple* (page 34), which is so sumptuous and ornate that it recalls Byzantine art, with Pietro's *Scenes of the Life of the Blessed Umiltà* (page 32), which has a limited but clear palette and a poetically simple grandeur.

15

Representatives of the school of Giotto brought the master's teaching to the threshold of the fifteenth century. Among them was Giottino, who painted his elegiac *Pietà* (page 40) presenting saints and humans sharing a silent sorrow; only the luminous colors ring out against the gold background. Of a slightly later date is Andrea Orcagna's majestic and dynamic *Saint Matthew* (page 39), whose folding triptych form recalls its original use on one of the pillars of the church of Orsanmichele.

An extraordinary artistic renewal spread from Florence at the beginning of the fifteenth century, and the seminal works from this period, which have made the Uffizi famous, express visually the explosion of Renaissance concepts: the establishment of perspective derived from precise mathematical rules (rather than those intuited by Giotto); the rediscovery of classical antiquity; the search for the ideal relationships among figures and settings; and the new central position of man as protagonist in history and as the measure of all things. For example, Masaccio's renderings of the Madonna and Child (pages 52, 53) are at once classical and Christian in inspiration. When Paolo Uccello assembled his great scenes of the Battle of San Romano (in three parts: the other two are in the Louvre and the National Gallery of London; pages 54-55), he took the nascent rules of perspective to the limit, rendering the epic battle scene unreal and bloodless, with merry-go-round horses and suits of armor, all

arranged stiffly within chessboard grids dramatically marked off by pikes, crossbows, and broken lances on the ground.

Among the fundamental advances of this period is the natural luminosity that infuses the colors in the *Magnoli Altarpiece* by Domenico Veneziano (page 56). The artist's stay in Florence was of great importance both to the local painting school and to Piero della Francesca, who worked side by side with Domenico on the frescoes of Saint Egidio (now lost). The paired portraits of the Duke and Duchess of Urbino (pages 62–65) are among the best-known works by Piero della Francesca; by the time he painted these he had already perfected his synthesis of perspective and luminosity.

Fra Filippo Lippi proved himself a restless experimenter, inventing influential prototypes for Florentine art such as the famous *Madonna and Child with Two Angels* (page 58), the first profane interpretation of a religious subject. Other artists made even more daring experiments, particularly Antonio Pollaiolo, who probed the dynamics of figure relationships and space, as in the two small tablets with the "Labors of Hercules" (pages 76, 77).

The Neoplatonic school assembled around the Medici brought ancient myths into fashion; Sandro Botticelli took these and made their symbolic and philosophical meanings his own. The Uffizi possesses the world's most important collection of these works, including his

Primavera (pages 88–89) and The Birth of Venus (pages 90–91). The fluid lines of his drawing and the aristocratic grace and melancholy of his figures reflect a bright moment of faith in humanistic ideals. But that moment passed, and near the end of the century Botticelli turned to a devout reworking of the most traditional religious motifs, as seen in the grandiose and radiant Coronation of the Virgin (page 93), only recently put back on display after a long restoration.

The Uffizi collection includes other works that introduced dramatic changes to Italian painting: works by Leonardo da Vinci, with their "scientific"—rather than idealized and symbolic—vision of nature. They include the *Baptism of Christ* (page 102), on which Leonardo worked alongside Verrocchio—whose workshop was the training ground for many talents at the end of the fifteenth century—and Leonardo's youthful *Annunciation* (page 103), with its traditional composition refreshed by the sfumato technique and by the painter's atmospheric filter, as well as his highly complex and revolutionary *Adoration of the Magi* (page 104).

Michelangelo transmitted a sculptural, sophisticated, and intellectual vision in his *Holy Family* (also known as the *Doni Tondo*; page 123). Recent restoration of this work shows the iridescent and strident colors borrowed by the first generations of Mannerist painters, who looked to Michelangelo as their master. This splendid

work, almost the only panel by Michelangelo, presents the holy family in a perfectly fused design, with the foreground figures contrasted by monochrome nudes in the background. Another tutelary artist of fundamental importance to Italian painting was Raphael. In the Uffizi are his moving *Madonna del Cardellino* (page 140) and the portrait of Pope Leo X (page 141), with its powerful colors and psychological insight.

The works of the Mannerists—Jacopo da Pontormo, Rosso Fiorentino, and the Sienese Domenico Beccafumi-mark the movement away from objective naturalism toward an intellectual style that is by turns deeply moving, mocking, or ironic. They feature an extension of shapes, the use of unnatural colors, the influence of prints from northern Europe, and the disruption of the equilibrium of fifteenth-century painting. Later in the sixteenth century Florentine Mannerists moved toward the precious and formal, as in the cold, courtly works by Bronzino, the ideal court portraitist, who was trusted by the Medici to present them in timeless, regal images. Florentine Mannerists then turned to the production of small, sophisticated paintings based on allegorical or mythological subjects.

Andrea Mantegna's *Portrait of a Cardinal* (page 73) is of particular interest, for recent restoration has revealed the brightness of its colors and the sculptural sense of the sharply defined face. Another masterpiece is his triptych

with *The Adoration of the Magi* in the center flanked by *The Ascension* and *The Circumcision* (page 74), where each of the three subjects has a different setting.

In contrast to these are the balanced and harmonious compositions of Perugino, which all share an unforced elegance and simplicity. The power of his pictorial style is particularly evident in the *Pietà* (page 94), in which large arches set off the scene in a classical tableau of grief. Also in the collection are the powerful panels by Luca Signorelli, including the tondo of the Holy Family (page 97), crammed with intersecting views of bodies and books.

Correggio, whose mellow paintings are permeated with tenderness, as in the languid Adoration of the Child (page 155), was a point of reference in the sixteenth century, and he influenced artists beyond the local school. Beyond Tuscany, other fifteenth-century Italian schools of painting are well represented in the Uffizi, including pieces of fundamental importance from the Veneto region. The works by Giovanni Bellini, for example, include the mysterious Sacred Allegory and the monochrome Lamentation over the Body of Christ (page 70) as well as the grandiose Saint Jerome. At the end of the century, and well into the sixteenth century, the dominant artist in the Veneto was Titian, who throughout his long life was ever attentive to changes in the artistic climate. His masterpieces hang side by side in the Uffizi, including the *Venus of Urbino* (page 153), which entered the Medici collection in 1631 with the marriage of Vittoria della Rovere to Ferdinando II. That work offers an expression of full Renaissance opulence; Titian later showed his awareness of the Mannerist style with his *Venus and Cupid*. The collection also includes works by Titian's successors, such as the luminous and expansive paintings of Paolo Veronese and the shadowy, visionary works of Tintoretto.

Parmigianino's works display a certain softness based on the influence of Correggio as well as his virtuosity as a colorist, his elegantly elongated figures, and the ambiguity in their faces. Dosso Dossi of Ferrara (like Parmigianino, from the region of Emilia) was of a somewhat tougher temper and used brighter colors as well as unsettling symbolism, as in *Witchcraft* (page 156).

The more exaggerated and Baroque aspects of Mannerism gave way to the styles of Caravaggio and of Annibale Carracci later in the sixteenth century. Caravaggio took the tradition of Lombard realism to new heights with his dramatic use of lighting and sense of proximity to the scene. In his Young Bacchus (page 205), the mythological character is presented without disguise, in a rendering that has the lucid brilliance of a still life. The same detachment from myth can be seen in the vigorous and deeply felt Sacrifice of Isaac (page 203), with its peasant brutality, and in the Medusa (page 204), which

abandons the sterility of the ancient symbol to confront the viewer with the startling image of a bloody severed head. In comparison to these works is the great *Venus with Satyr and Cupids* (page 201) by Annibale Carracci, which demonstrates a more conventional technique, but with rich impasto and expanded forms, and a closer adhesion to classical myth.

Little else from the seventeenth century in Italy is on view in the main galleries, for most of the works of that period are displayed in the long Vasari Corridor or are still in storage awaiting the expansion of the Uffizi. Even so, there is a broad selection of works by painters from throughout the peninsula, including the formidable Artemisia Gentileschi, whose fame as an artist and as a woman has been revived by recent exhibitions and publications. The Uffizi presents, among other works, her celebrated *Judith and Holofernes* (page 215), once the emblem of international feminism.

The Italian eighteenth century appears with such brilliant personalities as Giuseppe Maria Crespi from Bologna and Alessandro Magnasco of Genoa. Magnasco's gloomy or stormy scenes are peopled by priests and gypsies rendered with caustic humor; Crespi was an affectionate observer of the everyday life of common people. Grand Prince Ferdinando de' Medici was quickly won over by the immediacy and liveliness of Crespi's works, and almost all the paintings by Crespi in the Uffizi were

made for him, including *The Painter's Family* and *The Flea* (page 230).

Above all, however, it is the Veneto school that represents the pictorial aspects of the Age of Enlightenment. Pietro Longhi in *The Confession* (a subject that would have been dear to Crespi; page 240) observes contemporary society without the bitter irony of his contemporary, William Hogarth. In contrast with Longhi's more traditional and often more robust characters are masterful works in pastel by the great portraitist Rosalba Carriera (the portrait of Felicità Sartori, page 233, is an example), known for the attractive faces of her women and female allegorical figures.

With technical virtuosity and colors drenched in light, Giovanni Battista Tiepolo created masterpieces of the great tradition of grandiloquent paintings that decorated ceilings (which explains why the view is from below, looking up) with his *Erection of a Statue to an Emperor* (page 236). The rational and scientific side of the century is more evident in Canaletto's famous views of Venice (*The Ducal Palace and Piazza San Marco*; page 239), in which the landscape, although rendered with faithful clarity, takes on an elegiac air thanks to the subdued colors and the theatrical composition.

PISAN SCHOOL (late 12th century) Crucifix with Stories of the Passion, n.d. Tempera on wood, 12 ft. 3 in. \times 8 ft. 6 in. (3.77 \times 2.31 m.)

Master of the San Francesco Bardi (active 1240–1270) Crucifix with Stories of the Passion, n.d. Tempera on wood, $97\frac{1}{2} \times 78$ in. (250 × 200 cm)

MASTER OF THE SAN FRANCESCO BARDI (active 1240–1270) Saint Francis Receiving the Stigmata, c. 1250 Tempera on wood, $31\frac{1}{2} \times 20$ in. $(81 \times 51 \text{ cm})$

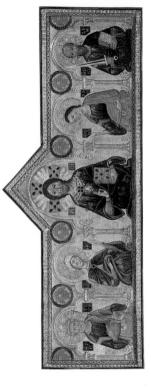

MELIORE DI JACOPO (active in Florence in 1260) Altarpiece with Redeemer and Saints Peter, Mary, John the Evangelist, and Paul, 1271 Tempera on wood, 33×82 in. $(85 \times 210 \text{ cm})$

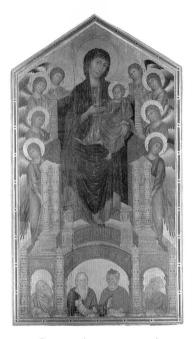

CIMABUE (c. 1240–c. 1302)

Maestà (Madonna Enthroned) with Angels
and Four Prophets, c. 1280

Tempera on wood, 12 ft. 6 in. × 7 ft. 3 in. (3.85 × 2.23 m.)

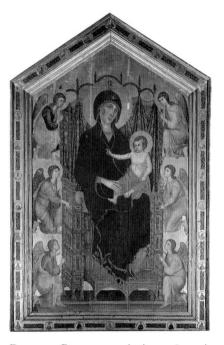

Duccio di Buoninsegna (active 1278-1319) *Maestà (Rucellai Madonna),* 1285 Tempera on wood, 14 ft. 7½ in. × 9 ft. 5 in. (4.50 × 2.90 m.)

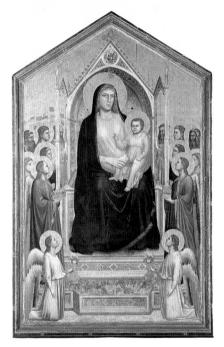

Giotto (c. 1266–c. 1337) *Madonna in Glory*, 1310 Tempera on wood, 126¾ × 79½ in. (325 × 204 cm)

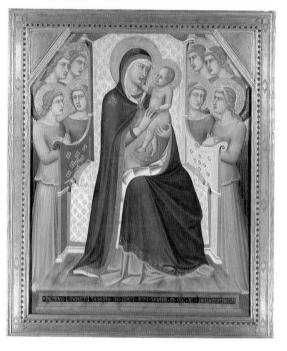

PIETRO LORENZETTI (c. 1280–c. 1348) Madonna Enthroned with Angels, early 1340s Tempera on wood, $56\frac{1}{2} \times 47\frac{1}{2}$ in. (145 × 122 cm)

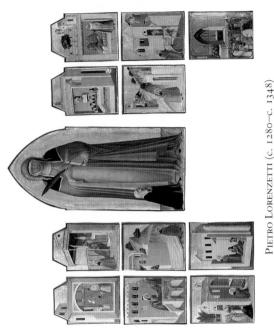

 $(128 \times 57 \text{ cm})$ Scenes of the Life of the Blessed Umiltà, a Tempera on wood, 50×22 in.

Tempera on wood, each panel: $37\% \times 13\%$ in. (96 × 35 cm) AMBROGIO LORENZETTI (1285–1348) Scenes from the Life of Saint Nicholas, 1330

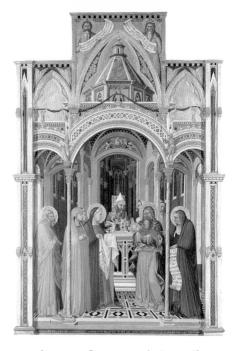

Ambrogio Lorenzetti (1285–1348) The Presentation in the Temple, 1342 Tempera on wood, $100 \times 65\frac{1}{2}$ in. $(257 \times 168 \text{ cm})$

MASTER OF SAINT CECILIA (active c. 1300—1320) Scenes from the Life of Saint Cecilia, after 1304 Tempera on wood, $33 \times 71\%$ in. $(85 \times 181 \text{ cm})$

The Annunciation and Two Saints, 1333 Tempera on wood, $71\% \times 82$ in. (184 × 210 cm) and Lippo Memmi (active in Siena 1317–1347) SIMONE MARTINI (C. 1283–1344)

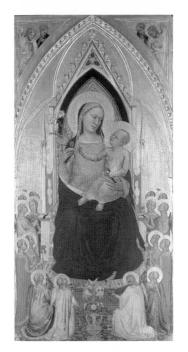

Bernardo Daddi (c. 1290–1348) Central panel of *Polyptych of Saint Pancras*, 1335–40 Tempera on wood, $65 \times 33\frac{1}{2}$ in. $(165 \times 85 \text{ cm})$

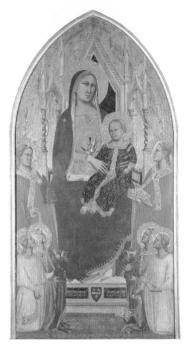

Taddeo Gaddi (c. 1300–c. 1366) *Madonna in Glory*, 1355 Tempera on wood, 60 × 31 in. (154 × 80 cm)

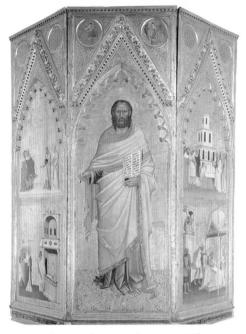

Andrea Orcagna (c. 1320–1368) and Jacopo di Cione (c. 1330–1398) Saint Matthew and Stories of His Life, c. 1367–70 Tempera on wood, 113½ × 103 in. (291 × 265 cm) overall

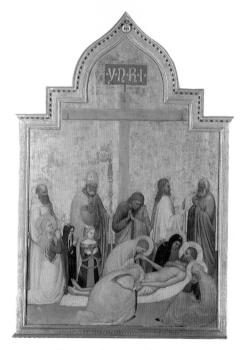

Giottino (c. 1325–after 1369) Pietà, 1360–65 Tempera on wood, 76×52 in. (195 × 134 cm)

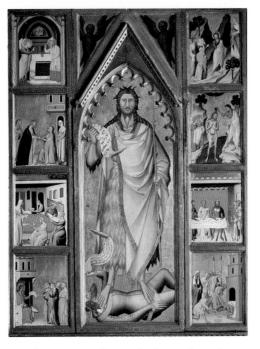

GIOVANNI DEL BIONDO (active 1356–1399) Saint John the Evangelist and Stories from His Life, n.d. Tempera on wood, $107\frac{1}{4} \times 70$ in. $(275 \times 180$ cm) overall

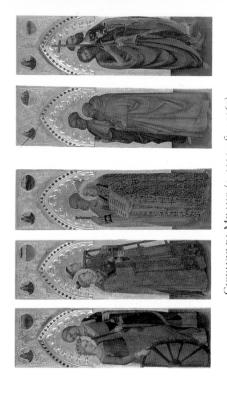

Tempera on wood, each panel: $52 \times 15\%$ in. $(132 \times 39 \text{ cm})$ Ognissanti Polyptych (upper panels), c. 1360 Giovanni da Milano (c. 1325–after 1369)

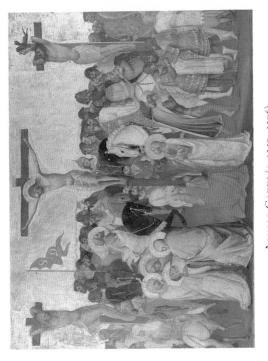

Tempera on wood, 23×30 in. $(59 \times 77$ cm) AGNOLO GADDI (c. 1350–1396) The Crucifixion, 1390–96

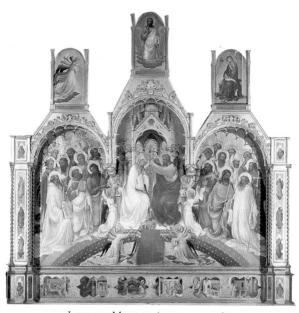

 $\begin{array}{c} LORENZO\ MONACO\ (c.\ 1370-1425?) \\ \hline \textit{The Coronation of the Virgin,}\ 1413 \\ Tempera\ on\ wood,\ 14\ ft.\ 7\frac{1}{2}\ in.\times 11\ ft.\ 4\frac{1}{2}\ in.\ (4.50\times 3.50\ m.) \end{array}$

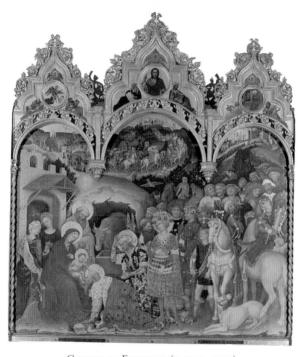

Gentile da Fabriano (c. 1370–1427) The Adoration of the Magi, 1423 Tempera on wood, 117 × 111 in. (300 × 283 cm)

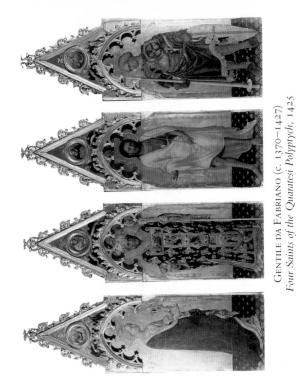

Tempera on wood, each panel: $78 \times 23\%$ in. $(200 \times 60 \text{ cm})$

46

Traditionally attributed to GHERARDO STARNINA (active c. 1387-1409) Tempera on wood, $31 \times 84\%$ in. $(80 \times 216 \text{ cm})$ The Thebaid, n.d.

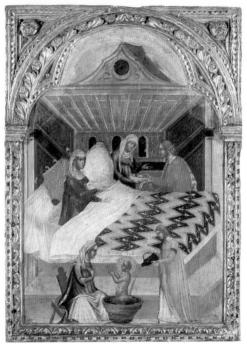

PAOLO VENEZIANO (active c. 1333-1362) *The Birth of Saint Nicholas*, c. 1346Tempera on wood, 29×21 in. $(74.5 \times 54.5$ cm)

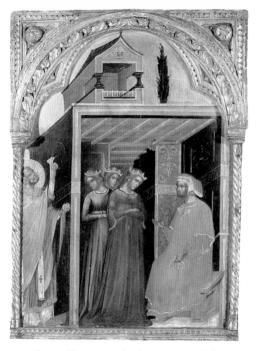

PAOLO VENEZIANO (active c. 1333–1362) The Charity of Saint Nicholas, c. 1346 Tempera on wood, $28\frac{1}{2} \times 20\frac{1}{2}$ in. $(73 \times 53$ cm)

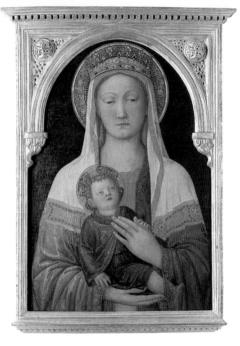

JACOPO BELLINI (c. 1400–1470) Madonna and Child, c. 1450 Tempera on wood, $28\frac{1}{2} \times 22$ in. $(73 \times 57$ cm)

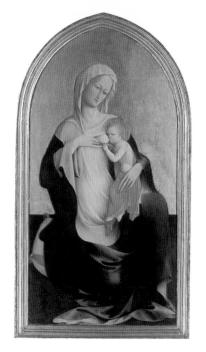

Masolino da Panicale (1383–c. 1447) Madonna~of~Humility,~1430–35 Tempera on wood, 43 × 24 in. (110.5 × 62 cm)

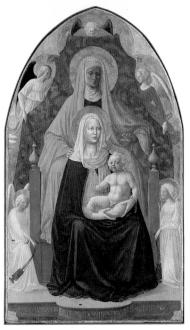

MASOLINO DA PANICALE (1383–C. 1447) and MASACCIO (1401–1428?) Madonna and Child with Saint Anne, 1424–25 Tempera on wood, 68¼ × 40 in. (175 × 103 cm)

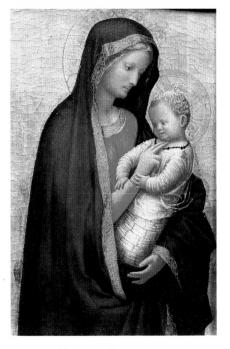

MASACCIO (1401–1428?) Madonna and Child, c. 1426 Tempera on wood, $9\frac{1}{2} \times 7$ in. (24.5 × 18.2 cm)

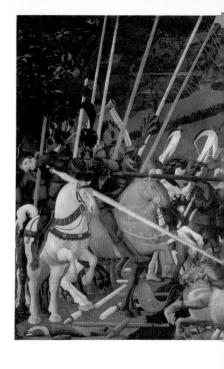

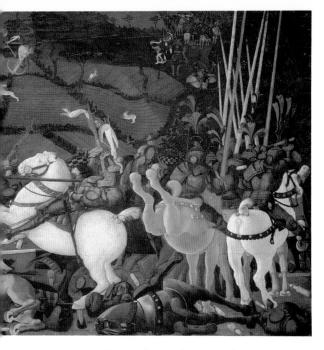

PAOLO UCCELLO (1397–1475)

The Battle of San Romano, c. 1456
Tempera on wood, 71 × 86 in. (182 × 220 cm)

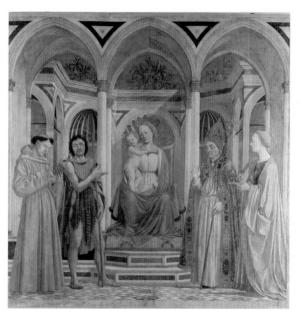

Domenico Veneziano (c. 1400–1461) Madonna and Child with Saints (Magnoli Altarpiece), 1440–50 Tempera on wood, $81\frac{1}{2} \times 84\frac{1}{4}$ in. (209 \times 216 cm)

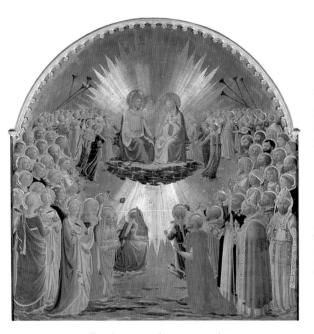

FRA ANGELICO (c. 1400-1455) *The Coronation of the Virgin*, c. 1435

Tempera on wood, 43³/₄ × 44¹/₂ in. (112 × 114 cm)

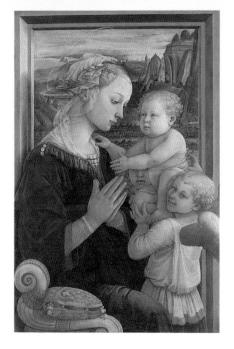

FRA FILIPPO LIPPI (c. 1406-1469)

Madonna and Child with Two Angels, c. 1464Tempera on wood, 37×24 in. $(95 \times 62$ cm)

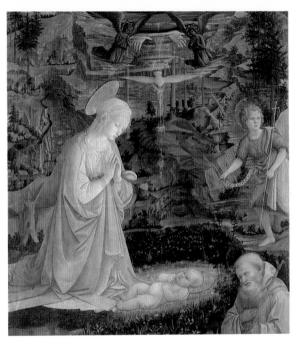

Fra Filippo Lippi (c. 1406–1469) The Adoration of the Child, c. 1463 Tempera on wood, $55\% \times 51\%$ in. (140 × 130 cm)

Tempera on wood, 86×112 in. $(220 \times 287$ cm) Fra Filippo Lippi (c. 1406–1469) The Coronation of the Virgin, 1441–47

Vecchietta (Lorenzo di Pietro) (c. 1410–1480) Tempera on wood, 61×90 in. $(156 \times 230 \text{ cm})$ Madonna and Child Enthroned with Saints, 1457

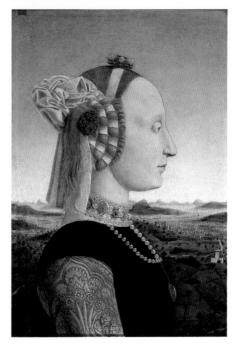

PIERO DELLA FRANCESCA (c. 1420–1492) The Duchess of Urbino, 1465–70 Tempera on wood, 18×13 in. $(47 \times 33$ cm)

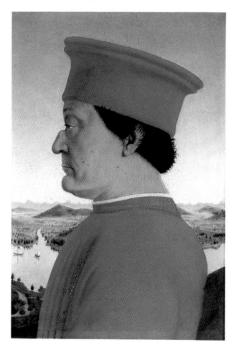

Piero Della Francesca (c. 1420–1492) The Duke of Urbino, 1465–70 Tempera on wood, 18×13 in. $(47 \times 33$ cm)

QVE MODUM REBUS TENVIT SECVNIDIS -CONIV GIS MAGNI DECORATA RERVM + LAVDE GESTARVM VOLITAT PER ORA -CVNCTA VIRORVM -

Piero della Francesca (c. 1420–1492) The Duchess of Urbino (verso), 1465–70 Tempera on wood, 18 × 13 in. (47 × 33 cm)

CLARVS INSIGNI VEHITVR TRIVMPHO

QVEM PAREM SVMMIS DVCIBVS PERHENNIS .
FAMA VIRTVTVM CELEBRAT DECENTER .
SCEPTRA TENENTEM ...

PIERO DELLA FRANCESCA (c. 1420–1492) The Duke of Urbino (verso), 1465–70 Tempera on wood, 18 × 13 in. (47 × 33 cm)

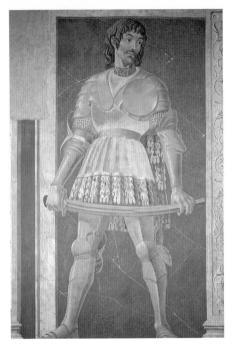

Andrea del Castagno (c. 1421–1457) Pippo Spano (from the series Illustrious Men), c. 1450 Detached fresco, 983/8 × 605/8 in. (250 × 154 cm)

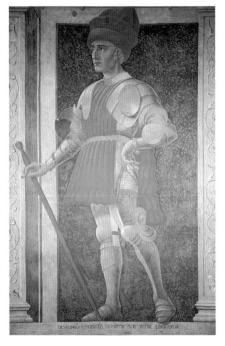

Andrea del Castagno (c. 1421–1457) Farinata degli Uberti (from the series Illustrious Men), c. 1450 Detached fresco, 983/s × 605/s in. (250 × 154 cm)

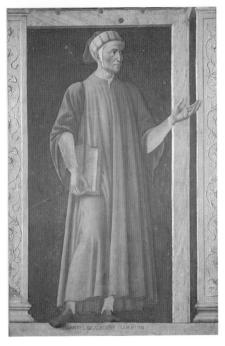

Andrea del Castagno (c. 1421–1457) Dante Alighieri (from the series Illustrious Men), c. 1450 Detached fresco, 97¼ × 60¼ in. (247 × 153 cm)

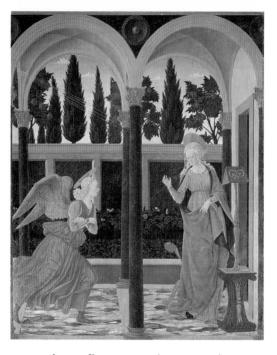

Alessio Baldovinetti (c. 1425–1499) The Annunciation, 1457 Tempera on wood, $65 \times 53\frac{1}{2}$ in. (167×137 cm)

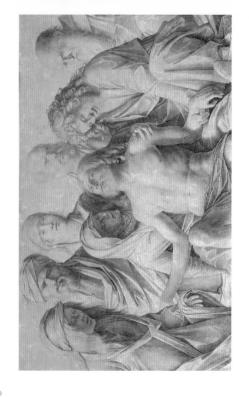

GIOVANNI BELLINI (c. 1430–1516) The Lamentation over the Body of Christ, c. 1500 Tempera on wood, 29×46 in. $(74 \times 118$ cm)

VINCENZO FOPPA (c. 1427–c. 1515) Madonna and Child with Angel, 1479/80 Tempera on wood, $16 \times 12\frac{1}{2}$ in. $(41 \times 32.5$ cm)

Andrea Mantegna (1431–1506) Madonna~and~Child,~c.~1446 Tempera on wood, 11 \times 8½ in. (29 \times 21.5 cm)

Andrea Mantegna (1431–1506) Portrait of a Cardinal, 1459/66 Tempera on wood, $16\times11^{1/2}$ in. (40.4 \times 29.5 cm)

Andrea Mantegna (1431–1506) The Ascension, The Adoration of the Magi, and The Circumcision, 1463/67 Tempera on wood, $34 \times 63\%$ in. $(86.5 \times 161.5 \text{ cm})$ overall

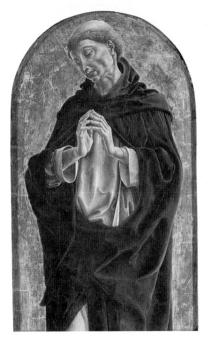

Cosmè Tura (c. 1430–1495) Saint Dominic, c. 1475 Tempera on wood, $20 \times 12^{1/2}$ in. (51 \times 32 cm)

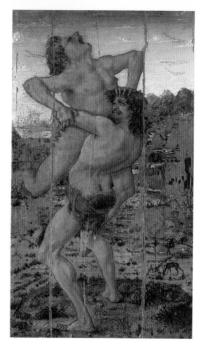

Antonio Pollaiolo (c. 1431–1498) Hercules and Antaeus, c. 1460 Tempera on wood, $6\frac{1}{4} \times 3\frac{1}{2}$ in. $(16 \times 9 \text{ cm})$

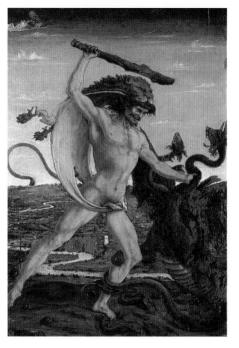

Antonio Pollaiolo (c. 1431–1498) Hercules and the Hydra, c. 1460 Tempera on wood, $6^{3}/4 \times 4^{1}/2$ in. (17 \times 12 cm)

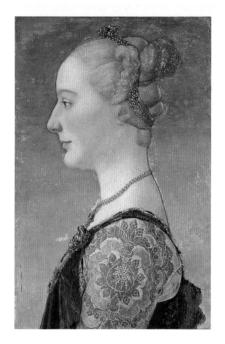

Antonio Pollaiolo (c. 1431–1498) Portrait of a Young Woman, c. 1475 Tempera on wood, $21\frac{1}{2} \times 13\frac{3}{4}$ in. (55 \times 34 cm)

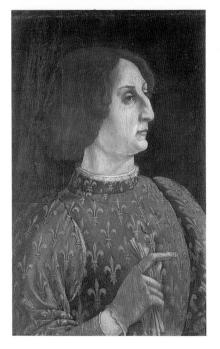

Piero Pollaiolo (1443–1496) Galeazzo Maria Sforza, 1471 Tempera on wood, 25 \times 16 in. (65 \times 42 cm)

Piero Pollaiolo (1443–1496) $Charity,\ 1469$ Tempera on wood, 65×34 in. (167 \times 88 cm)

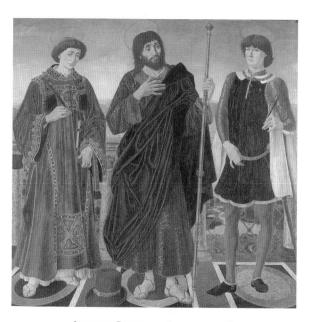

Antonio Pollaiolo (c. 1431–1498) and Piero Pollaiolo (1443–1496) Saints Vincent, James, and Eustace, c. 1467 Tempera on wood, 67 × 70 in. (172 × 179 cm)

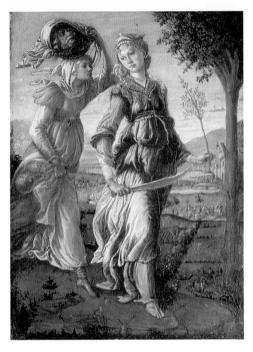

Sandro Botticelli (1445–1510) The Return of Judith, c. 1470 Tempera on wood, $12\frac{1}{4} \times 9\frac{1}{2}$ in. (31 × 24 cm)

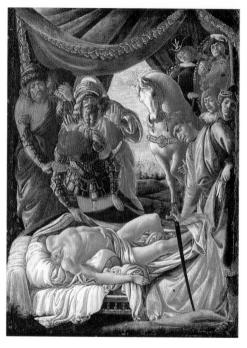

Sandro Botticelli (1445–1510) Discovery of the Body of Holofernes, before 1480 Tempera on wood, $12 \times 9^{3/4}$ in. $(31 \times 25 \text{ cm})$

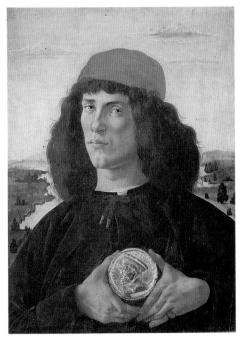

Sandro Botticelli (1445–1510) Portrait of a Young Man with a Medal, c. 1474–75 Tempera on wood, $22\frac{3}{4} \times 17\frac{3}{8}$ in. (57.5 × 44 cm)

SANDRO BOTTICELLI (1445-1510) The Adoration of the Magi, c Tempera on wood, $43\frac{1}{2} \times 52\frac{3}{4}$ in.

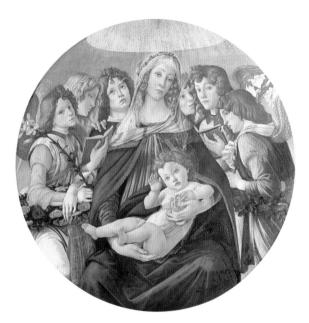

SANDRO BOTTICELLI (1445–1510) Madonna of the Pomegranate, before 1490 Tempera on wood, diameter: 56 in. (143.5 cm)

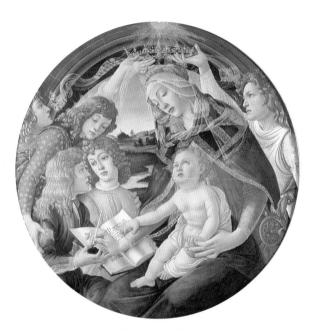

Sandro Botticelli (1445–1510) *Madonna of the Magnificat,* before 1490 Tempera on wood, diameter: 46 in. (118 cm)

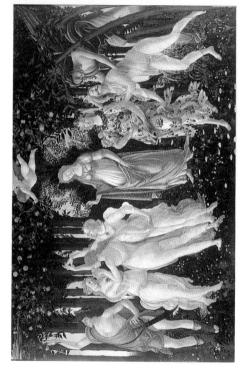

Tempera on wood, $79\% \times 123\%$ in. $(203 \times 314 \text{ cm})$ SANDRO BOTTICELLI (1445-1510) Primavera, 1477-80

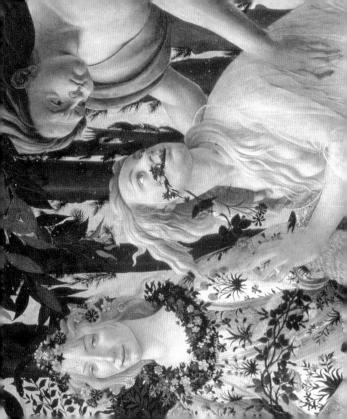

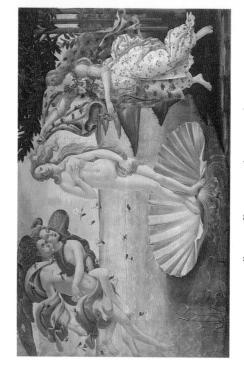

Sandro Botticelli (1445–1510) $The\ Birth\ of\ Venus,\ c.\ 1480$ Tempera on canvas, 67/4 × 108 in. (172.5 × 278.5 cm)

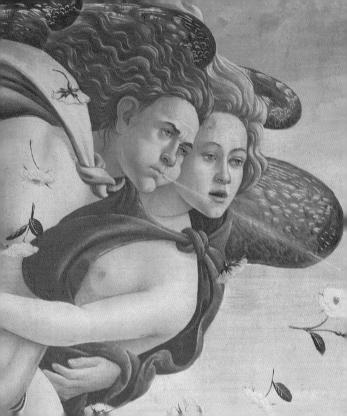

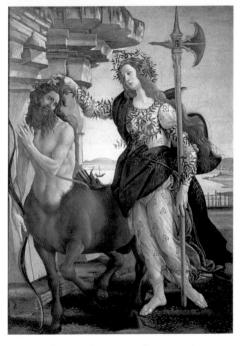

Sandro Botticelli (1445–1510) Pallas and the Centaur, n.d. Tempera on canvas, $80\frac{3}{4} \times 57\frac{3}{4}$ in. (207 × 148 cm)

Sandro Botticelli (1445–1510) The Coronation of the Virgin, c. 1489 Tempera on wood, 12 ft. $3\frac{1}{2}$ in. \times 8 ft. $5\frac{5}{8}$ in. (3.78 \times 25.8 m.)

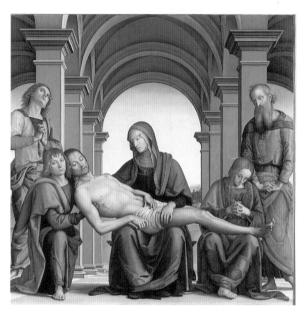

Perugino (c. 1445–1523) Pietà, 1493/94 Tempera on wood, 65½ × 68½ in. (168 × 176 cm)

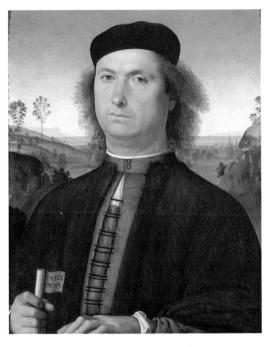

Perugino (c. 1445–1523) Francesco delle Opere, 1494 Tempera on wood, 20 \times 17 in. (52 \times 44 cm)

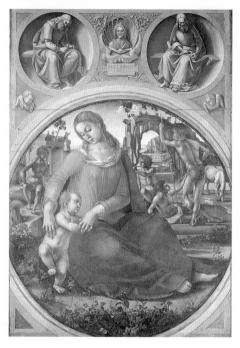

Luca Signorelli (1441?–1523) *Madonna and Child*, 1490–95 Oil on wood, 66 × 46 in. (170 × 117.5 cm)

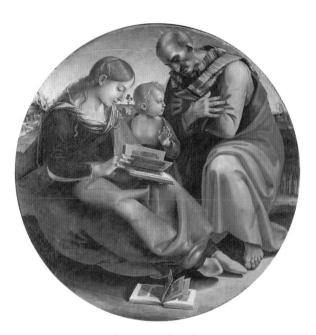

Luca Signorelli (1441?–1523) *The Holy Family*, c. 1490 Oil on wood, diameter: 48 in. (124 cm)

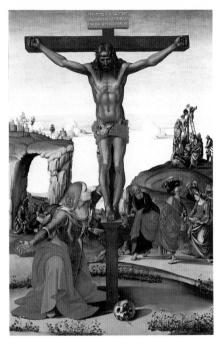

LUCA SIGNORELLI (1441?–1523)

The Crucifixion with Mary Magdalene, c. 1500

Oil on canvas, 96 × 64 in. (247 × 165 cm)

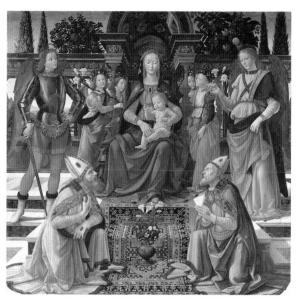

Domenico Ghirlandaio (1449–1494) *Madonna Enthroned with Saints*, c. 1484 Tempera on wood, 74×78 in. (190 \times 200 cm)

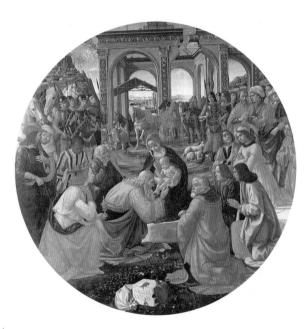

Domenico Ghirlandaio (1449–1494) The Adoration of the Magi, 1487 Tempera on wood, diameter: 67 in. (172 cm)

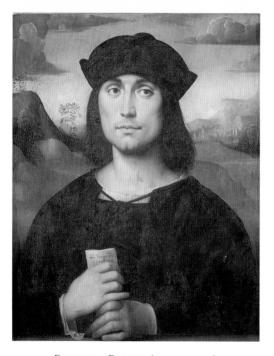

Francesco Francia (c. 1450–1517) *Evangelista Scappi*, 1500/1505

Tempera on wood, 21½ × 17 in. (55 × 44 cm)

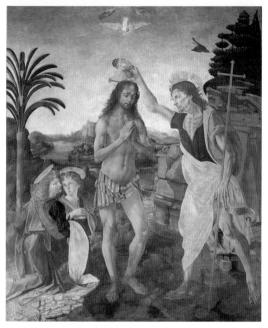

Andrea Verrocchio (1435–1488) and Leonardo da Vinci (1452–15) The Baptism of Christ, c. 1475 Oil on wood, 70 x 59½ in. (180 x 152 cm)

The Annunciation, c. 1472-75 Oil on wood, $34\% \times 84\%$ in. $(88 \times 217 \text{ cm})$ LEONARDO DA VINCI (1452–1519)

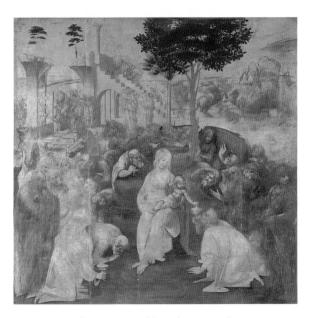

Leonardo da Vinci (1452–1519) The Adoration of the Magi, c. 1481 Tempera and oil on wood, 95×96 in. (243 \times 246 cm)

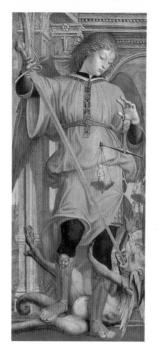

Bernardino Zenale (c. 1456–1526) Saint Michael Archangel, after 1480 Oil on wood, 45×20 in. (115 \times 51 cm)

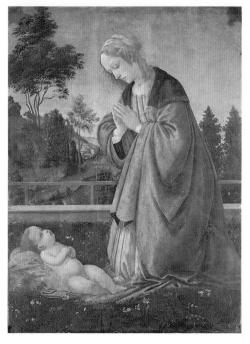

FILIPPINO LIPPI (c. 1457–1504) The Adoration of the Child, early 1480s Tempera on wood, $37\frac{1}{2} \times 27\frac{1}{2}$ in. (96 \times 71 cm)

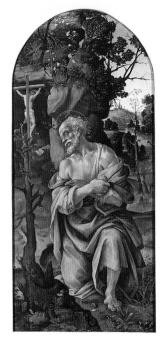

Filippino Lippi (c. 1457–1504) Saint Jerome, c. 1485 Tempera on wood, 53 \times 27% in. (136 \times 71 cm)

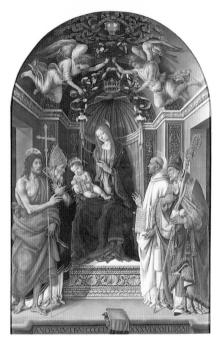

FILIPPINO LIPPI (c. 1457–1504) Madonna and Child (Madonna of the Otto), 1486 Tempera on wood, 138½ × 99½ in. (355 × 255 cm)

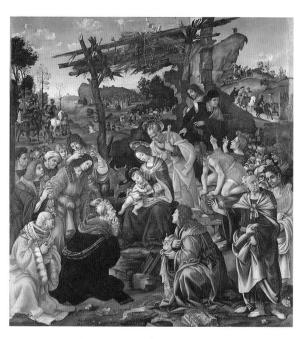

FILIPPINO LIPPI (c. 1457-1504) The Adoration of the Magi, 1496 Tempera on wood, $101\frac{1}{2} \times 95\frac{5}{8}$ in. $(258 \times 243 \text{ cm})$

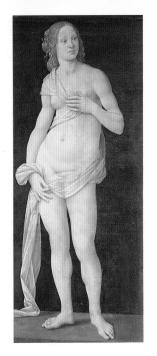

LORENZO DI CREDI (c. 1459–1537) Venus, c. 1490 Oil on canvas, 59×27 in. $(151 \times 69 \text{ cm})$

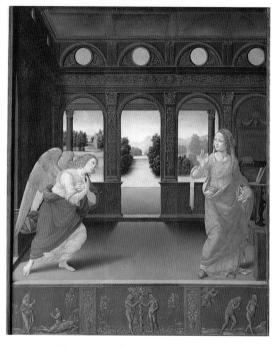

LORENZO DI CREDI (c. 1459–1537) The Annunciation, early 1480s Oil on wood, $34\frac{5}{8} \times 27\frac{1}{2}$ in. $(88 \times 71 \text{ cm})$

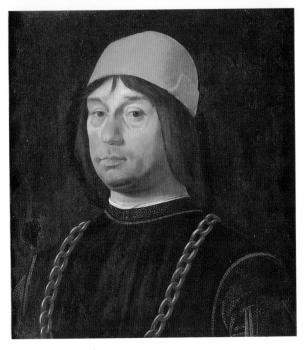

LORENZO COSTA (c. 1460–1535) Giovanni Bentivoglio, 1490–1500 Tempera on wood, $21\frac{1}{2} \times 19$ in. (55 \times 49 cm)

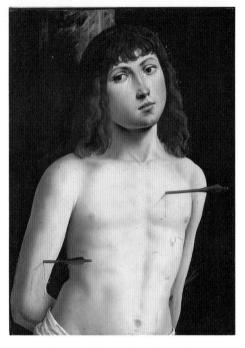

LORENZO COSTA (c. 1460–1535) Saint Sebastian, 1490–91 Tempera on wood, $21\frac{1}{2} \times 19$ in. $(55 \times 49$ cm)

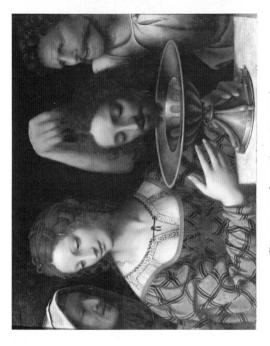

Executioner with the Head of John the Baptist (Herodias), 1527/31 Tempera on wood, $20 \times 22\%$ in. $(51 \times 58 \text{ cm})$ Bernardino Luini (c. 1460–1532)

PHERO DI COSIMO (1462–1521) Perseus Liberating Andromeda, c. 1513 Oil on wood, 27×48 in. $(70 \times 123 \text{ cm})$

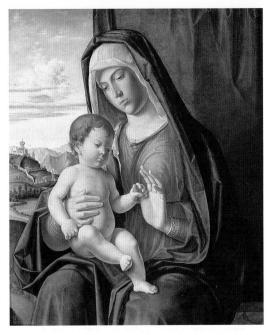

GIOVANNI BATTISTA CIMA DA CONEGLIANO (c. 1460–c. 1517) *Madonna and Child*, c. 1504

Oil on wood, 25³/₄ × 22 in. (66 × 57 cm)

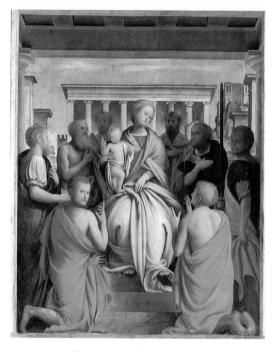

Bramantino (c. 1465–1530) *Madonna and Child with Saints*, c. 1520–30 Tempera on wood, 79×65 in. $(203 \times 167$ cm)

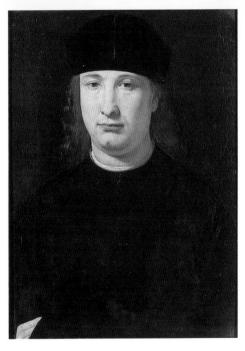

GIOVANNI ANTONIO BOLTRAFFIO (1467–1516) *The Poet Casio*, c. 1490–1500 Oil on wood, 20 × 14½ in. (51.5 × 37 cm)

VITTORE CARPACCIO (c. 1450–1526) *Warriors and Old Men*, 1493–1500 Oil on wood, 26½ × 16½ in. (68 × 42 cm)

Pietà, c. 1491 Tempera on wood, 24 × 61½ in. (62 × 158 cm) Lorenzo da Sanseverino (1468–1503)

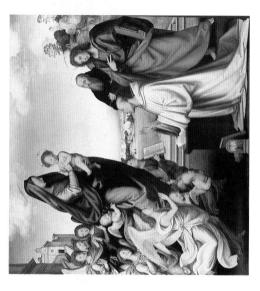

Fra Bartolomeo (1472–1517) The Appearance of the Virgin to Saint Bernard, 1504/7 Oil on wood, 84×90 in. $(215 \times 231$ cm)

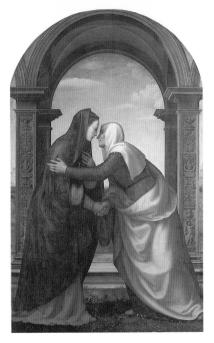

Mariotto Albertinelli (1474–1515) The Visitation, 1503 Tempera on wood, $90\frac{1}{2} \times 57$ in. (232 × 146 cm)

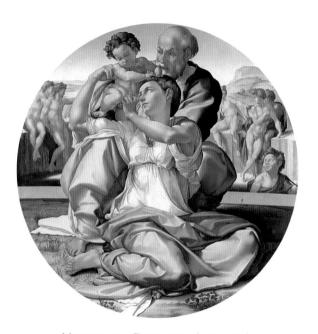

MICHELANGELO BUONARROTI (1475–1564) The Holy Family (The Doni Tondo), 1504 Tempera on wood, diameter: 47½ in. (120 cm)

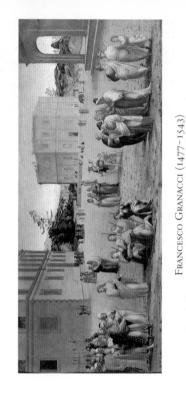

Joseph Presents His Father and Brothers to the Pharaoh, c. 1515 Tempera on wood, 37×87 in. $(95 \times 224$ cm)

124

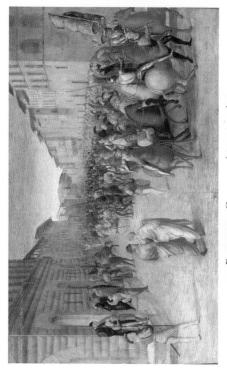

Tempera on wood, $30 \times 48\%$ in. (76×122 cm) Francesco Granacci (1477–1543) Entry of Charles VIII into Florence, c. 1518

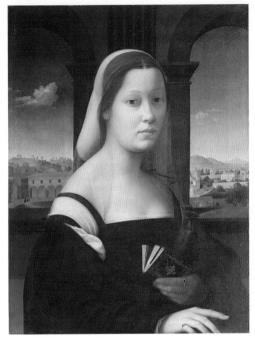

Gil Liano Bugiardini (1476–1555) Portrait of a Woman, 1506–10 Tempera on wood, $25\frac{1}{2} \times 18\frac{1}{2}$ in. (65 \times 48 cm)

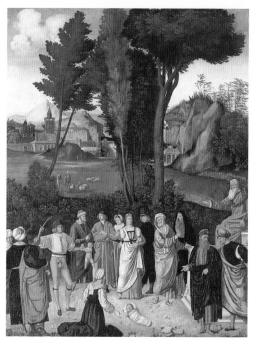

GIORGIONE (c. 1477–1510) The Judgment of Solomon, 1502–8 Oil on wood, 34¾ × 28 in. (89 × 72 cm)

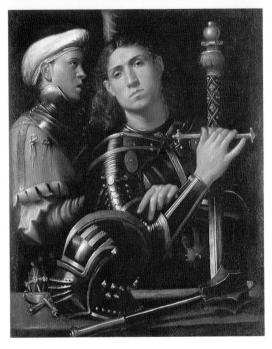

Attributed to Giorgione (c. 1477–1510) Warrior with Shield Bearer, n.d. Oil on canvas, $35 \times 28\frac{1}{2}$ in. (90 × 73 cm)

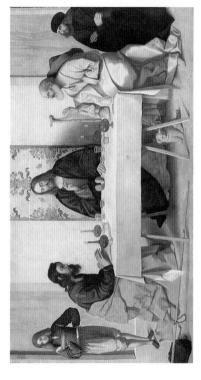

Vincenzo di Biagio Catena (c. 1470–1531) The Supper at Emmaus, 1520–30 Oil on canvas, 50¾ × 94 in. (130 × 241 cm)

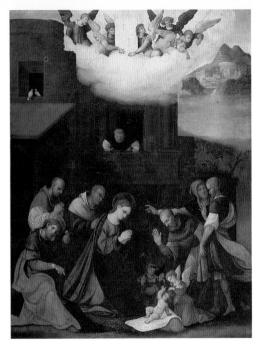

LUDOVICO MAZZOLINO (c. 1480–1528)

The Adoration of the Child, n.d.

Oil on wood, 31 × 23½ in. (79.5 × 60.5 cm)

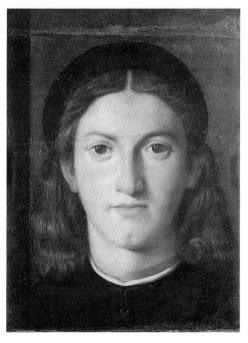

LORENZO LOTTO (c. 1480–1556) Head of a Young Man, early 1500s Oil on wood, $11 \times 8\frac{1}{2}$ in. $(28 \times 22$ cm)

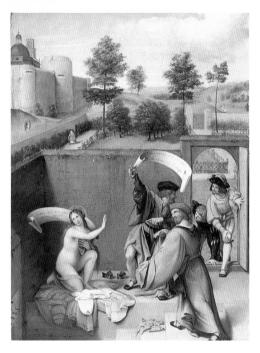

LORENZO LOTTO (c. 1480–1556) Susanna and the Elders, 1517 Oil on wood, $25\frac{34}{4} \times 19\frac{1}{2}$ in. (66 \times 50 cm)

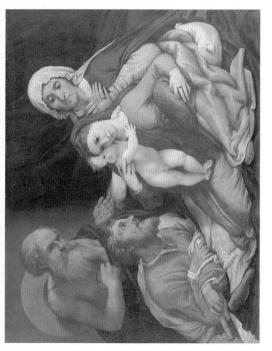

LORENZO LOTTO (c. 1480-1556)

Madonna and Child with Saints, 1534Oil on canvas, 27×34 in. $(69 \times 87.5 \text{ cm})$

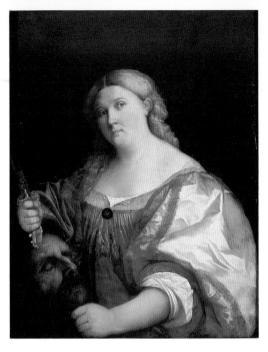

Palma Vecchio (c. 1480–1528) Judith, c. 1525/28 Oil on wood, 35 × 27½ in. (90 × 71 cm)

Palma Vecchio (c. 1480–1528) The Holy Family and Saints, n.d. Oil on wood, $34 \times 45\%$ in. $(87 \times 117 \text{ cm})$

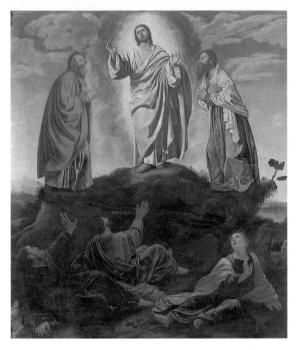

GIOVANNI GIROLAMO SAVOLDO (c. 1480–1548) *The Transfiguration*, 1520–40 Oil on wood, 54 × 49 in. (139 × 126 cm)

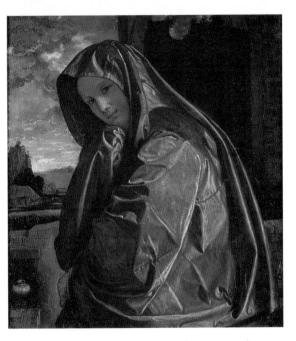

GIOVANNI GIROLAMO SAVOLDO (c. 1480–1548) Magdalene at the Tomb, n.d. Oil on canvas, 32¾ × 30¼ in. (84 × 77.5 cm)

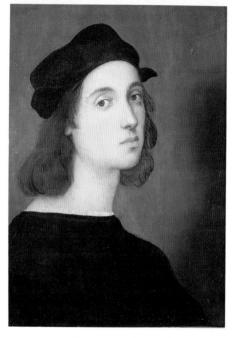

Raphael (1483–1520) *Self-Portrait*, c. 1506 Tempera on wood, 18½ × 13 in. (47.5 × 33 cm)

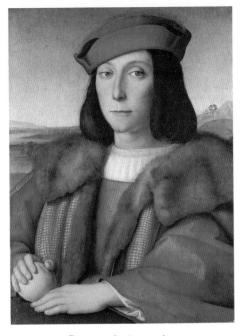

RAPHAEL (1483-1520)

Portrait of an Unknown Man

(Francesco Maria della Rovere?), 1503/4

Tempera on wood, 18³/₄ × 14 in. (48 × 35.5 cm)

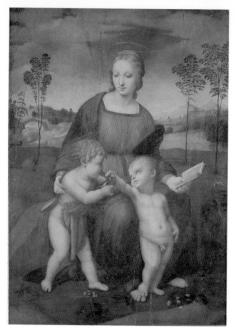

RAPHAEL (1483–1520)

Madonna and Child with Young Saint John
(Madonna del Cardellino), 1505–6

Oil on wood, 41¾ × 30 in. (107 × 77 cm)

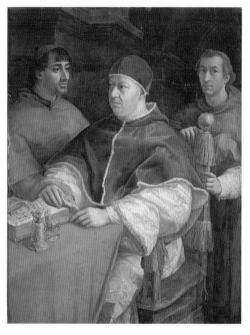

RAPHAEL (1483–1520)

Pope Leo X with Cardinals Giulio de' Medici
and Luigi de' Rossi, c. 1518

Oil on wood, 60½ × 46½ in. (155.5 × 119.5 cm)

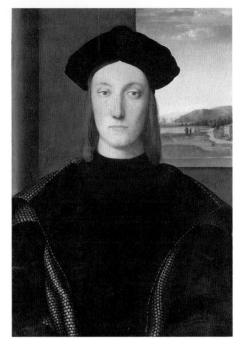

Raphael (1483–1520) Guidobaldo da Montefeltro, 1506 Tempera on wood, $27\frac{1}{2} \times 19\frac{1}{2}$ in. (70.5 \times 49.9 cm)

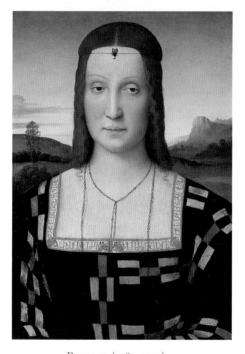

Raphael (1483-1520) Elisabetta Gonzaga, 1504-6 Tempera on wood, $20\frac{1}{2} \times 14\frac{1}{2}$ in. (52.5 \times 37.3 cm)

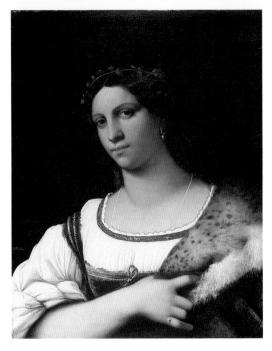

SEBASTIANO DEL PIOMBO (c. 1485–1547)

**Portrait of a Woman, 1512

Oil on wood, 26½ × 21½ in. (68 × 55 cm)

The Death of Adonis, early 1500s Oil on canvas, $73\% \times 111$ in. $(189 \times 285 \text{ cm})$ SEBASTIANO DEL PIOMBO (C. 1485–1547)

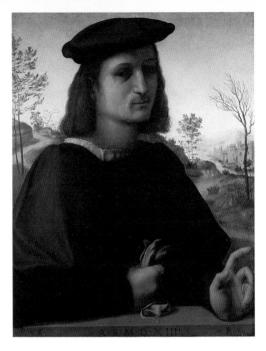

Franciabigio (1484–1525) Portrait of a Young Man with Gloves, n.d. Oil on wood, $23\frac{1}{2} \times 18$ in. (60 \times 47 cm)

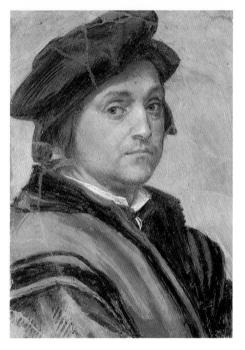

Andrea del Sarto (1486–1530) Self-Portrait, 1528–30 Fresco on tile, 20 \times 14 $\frac{1}{2}$ in. (51.5 \times 37.5 cm)

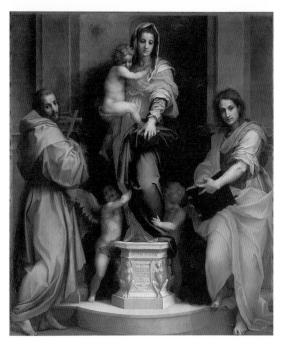

Andrea del Sarto (1486-1530) Madonna of the Harpies, 1517 Tempera on wood, $80\% \times 70$ in. $(207 \times 178$ cm)

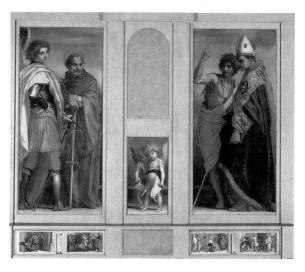

Andrea del Sarto (1486–1530) Four Saints from an Altarpiece (fragments), 1528 Tempera on wood, $71\frac{3}{4} \times 67$ in. (184 × 172 cm) overall

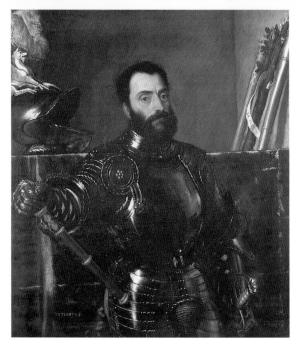

TITIAN (c. 1488–1576) Francesco Maria della Rovere, 1536–38 Oil on canvas, 44½ × 40 in. (114 × 103 cm)

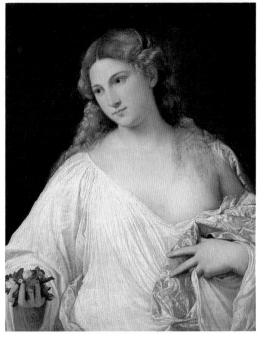

TITIAN (c. 1488–1576) Flora, c. 1515 Oil on canvas, $31 \times 24^{3/4}$ in. (79.7 \times 63.5 cm)

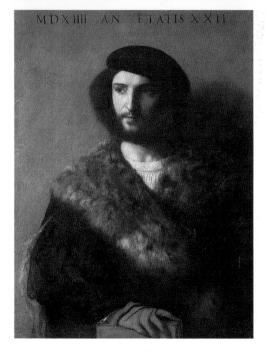

TITIAN (c. 1488-1576)

Portrait of the Sick Man, 1514Oil on canvas, $31\frac{1}{2} \times 23\frac{1}{4}$ in. $(81 \times 60 \text{ cm})$

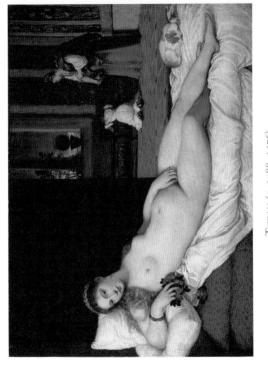

TITIAN (c. 1488–1576) The Venus of Urbino, c. 1538 Oil on canvas, $46/2 \times 65$ in. $(119 \times 165 \text{ cm})$

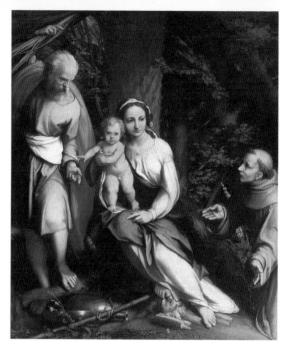

Correggio (1489–1534) The Rest on the Flight into Egypt, c. 1520 Oil on canvas, $48\times41\frac{1}{2}$ in. (123.5 \times 106.5 cm)

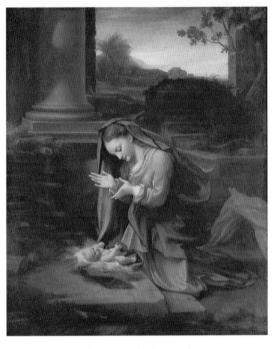

 $\begin{array}{c} CORREGGIO~(1489-1534)\\ \textit{The Adoration of the Child,}~1524/26\\ Oil on canvas,~31\frac{1}{2}\times30~in.~(81\times77~cm) \end{array}$

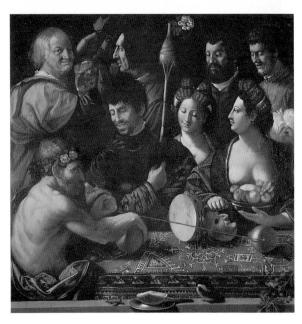

Dosso Dossi (1479?–1542) Witcheraft, 1535–40 Oil on canvas, $56\frac{1}{4} \times 56\frac{5}{6}$ in. (143 × 144 cm)

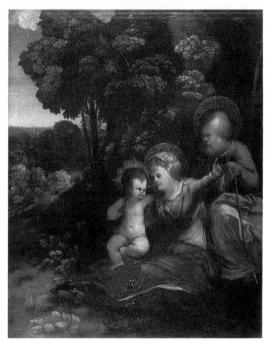

Dosso Dossi (1479?–1542) The Rest on the Flight into Egypt, early 1500s Tempera on wood, $20\% \times 16\%$ in. $(52 \times 42.6$ cm)

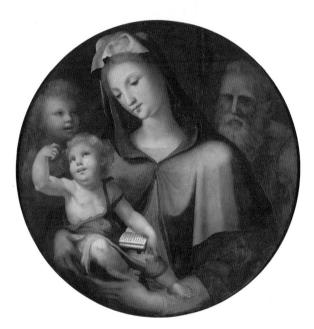

Domenico Beccafumi (c. 1486-1551) The Holy Family with Young Saint John, c. 1518 Tempera on wood, diameter: 32¾ in. (84 cm)

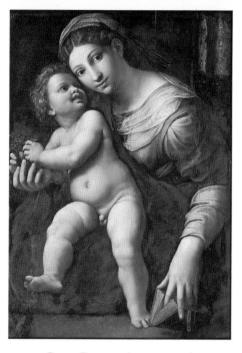

Giulio Romano (c. 1492–1546) *Madonna and Child*, 1520/30 Oil on wood, 76 × 30 in. (195 × 77 cm)

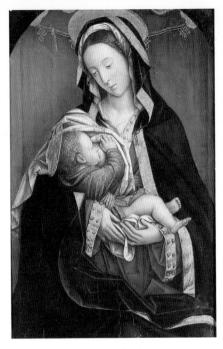

Defendente Ferrari (active 1510–1531) *Madonna and Child*, 1520–30

Oil on wood, 29¹/₄ × 19 in. (75 × 48.5 cm)

PONTORMO (1494–1556) Saint Anthony Abbot, c. 1518/19 Oil on wood, 30¾ × 26 in. (78 × 66 cm)

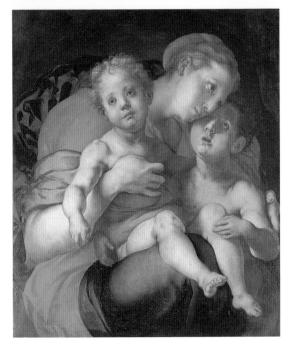

PONTORMO (1494-1556) Madonna and Child and Young Saint John, 1527/28 Tempera on wood, $34\frac{1}{2} \times 29$ in. $(89 \times 74$ cm)

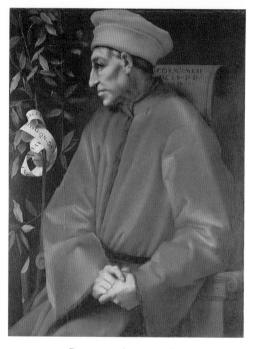

Pontormo (1494–1556) Cosimo the Elder, 1518/20 Tempera on wood, $33\frac{1}{2} \times 25\frac{1}{8}$ in. (86 \times 65 cm)

Pontormo (1494–1556) The Supper at Emmaus, 1525 Oil on canvas, $90 \times 67\frac{1}{2}$ in. (230 × 173 cm)

PONTORMO (1494-1556) The Birth of John the Baptist, 1527 Tempera on wood, diameter: 23 in. (59 cm)

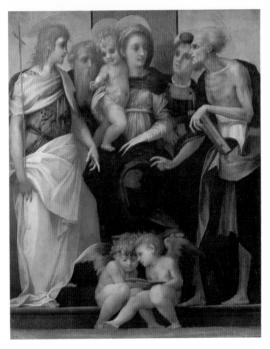

Rosso Fiorentino (1495-1540) Madonna and Child with Saints, 1518 Tempera on wood, 55 × 43½ in. (141 × 112 cm)

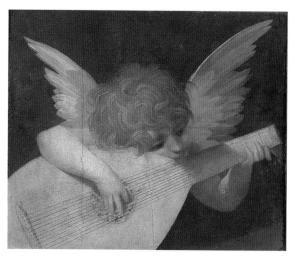

Rosso Fiorentino (1495–1540) Musical Angel, c. 1522 Tempera on wood, $15\frac{1}{4} \times 18\frac{1}{2}$ in. (39 \times 47 cm)

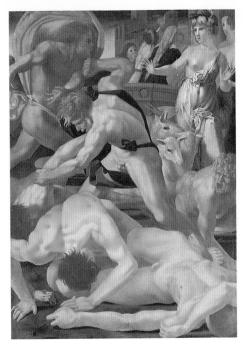

Rosso Fiorentino (1495–1540) Moses Defending the Daughters of Jethro, c. 1523 Oil on canvas, 62½ × 46 in. (160 × 117 cm)

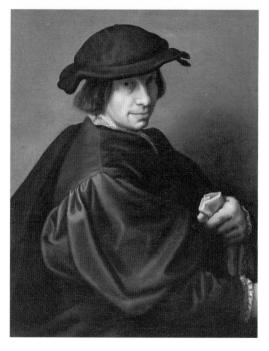

GIULIO CAMPI (1502–c. 1572) Portrait of the Artist's Father, c. 1535 Oil on canvas, $30\frac{1}{2} \times 24$ in. $(78.5 \times 62$ cm)

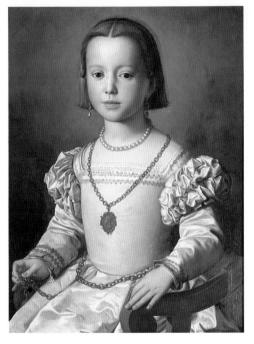

Bronzino (1503–1572) Bia, Illegitimate Daughter of Cosimo I de' Medici, before 1542 Oil on wood, 24½ × 19 in. (63 × 48 cm)

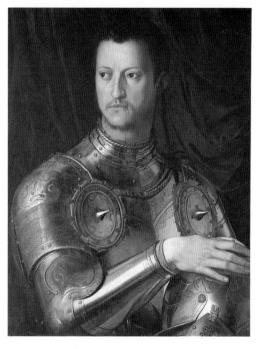

BRONZINO (1503–1572) Cosimo I de' Medici, c. 1545 Tempera on wood, $27\frac{1}{2} \times 22\frac{1}{4}$ in. (71 \times 57 cm)

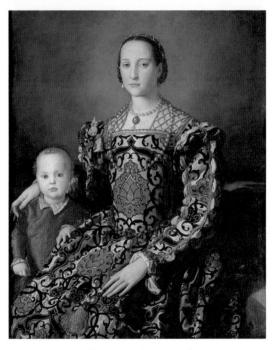

Bronzino (1503–1572) Eleanor of Toledo with Her Son Giovanni de' Medici, c. 1550 Tempera on wood, 45½ × 37¾ in. (115 × 96 cm)

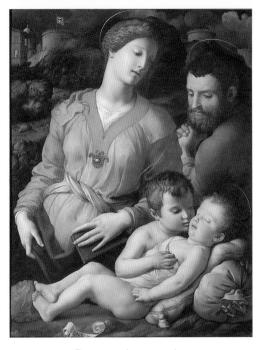

Bronzino (1503–1572) The Panciatichi Holy Family, c. 1540 Tempera on wood, $46\% \times 36\%$ in. (117 \times 93 cm)

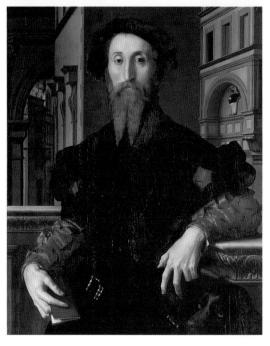

BRONZINO (1503–1572) Bartolomeo Panciatichi, n.d. Oil on wood, $40\frac{1}{2} \times 32\frac{3}{4}$ in. (104 \times 84 cm)

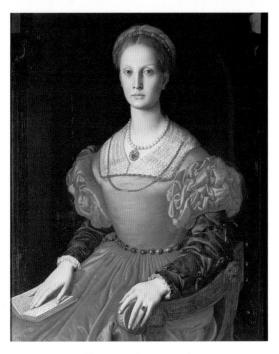

Bronzino (1503–1572) *Lucrezia Panciatichi*, c. 1540 Oil on wood, 39¾ × 33 in. (102 × 85 cm)

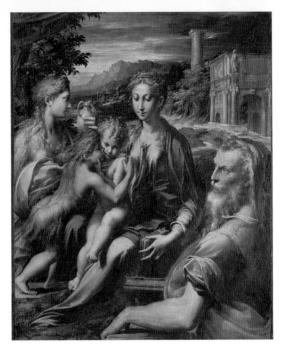

PARMIGIANINO (1503–1540) *Madonna of Saint Zachariah*, c. 1527–30 Oil on wood, 28½ × 23½ in. (73 × 60 cm)

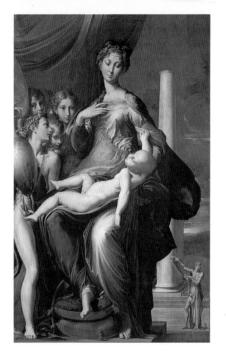

PARMIGIANINO (1503–1540) *Madonna with the Long Neck*, 1534–40 Oil on wood, 85½ × 52½ in. (219 × 135 cm)

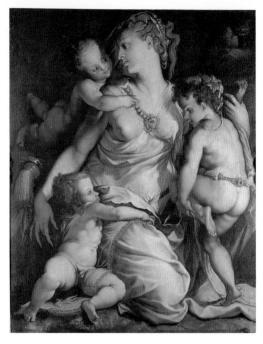

Francesco de' Rossi Salviati (1510–1563) $Charity, \ 1544-48$ Tempera on wood, $61 \times 47 \%$ in. (156 \times 122 cm)

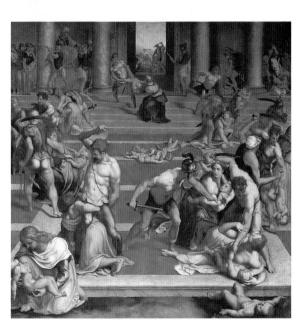

Daniele da Volterra (1509–1566) The Massacre of the Innocents, 1557 Tempera on wood, $20\% \times 16\%$ in. $(51 \times 42 \text{ cm})$

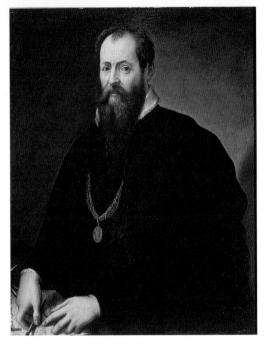

GIORGIO VASARI (1511–1574) *Self-Portrait*, n.d. Oil on wood, 39 × 31 in. (100.5 × 80 cm)

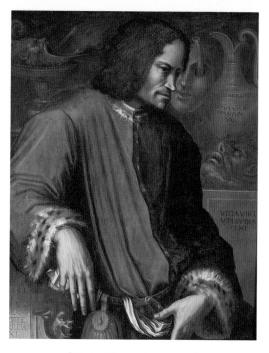

GIORGIO VASARI (1511–1574) Lorenzo the Magnificent, 1534 Oil on wood, 35×28 in. (90 \times 72 cm)

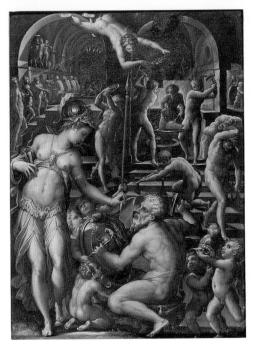

GIORGIO VASARI (1511–1574) Vulcan's Forge, n.d. Oil on copper, 15 \times 11 in. (38 \times 28 cm)

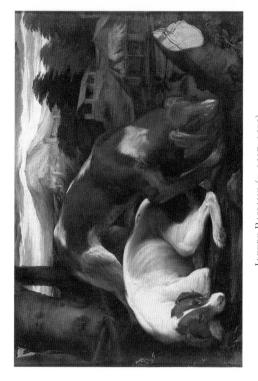

Jacopo Bassano (c. 1517–1592) Hunting Dogs, c. 1560 Oil on canvas, 33×49 in. $(85 \times 126 \text{ cm})$

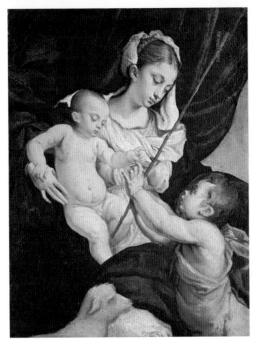

JACOPO BASSANO (c. 1517–1592) Madonna and Child with Saint John the Baptist, c. 1570 Oil on canvas, $31 \times 23 \frac{1}{4}$ in. (79 × 60 cm)

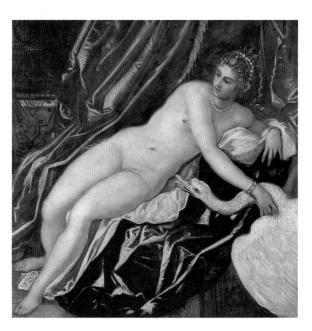

TINTORETTO (1518–1594) Leda and the Swan, c. 1550–60 Oil on canvas, 63 × 85 in. (162 × 218 cm)

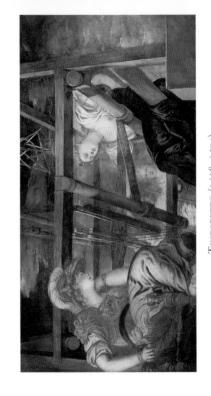

Oil on canvas, $56\% \times 106$ in. $(145 \times 272$ cm) Minerva and Arachne, c. 1570-80 TINTORETTO (1518-1594)

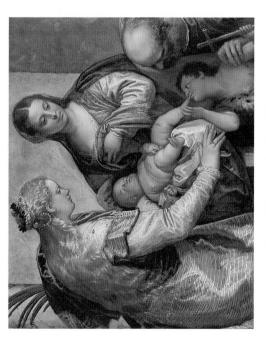

PAOLO VERONESE (1528–1588) The Holy Family with Saint Barbara and Young Saint John, 1550/65 Oil on canvas, $33\frac{1}{2} \times 47\frac{1}{2}$ in. (86 × 122 cm)

Oil on canvas, $55^{3/4} \times 111^{1/2}$ in. $(143 \times 291 \text{ cm})$ PAOLO VERONESE (1528–1588) *The Annunciation*, 1550–60

Paolo Veronese (1528–1588) The Maryrdom of Saint Justina, 1570–80 Oil on canvas, 40×44 in. (103 \times 113 cm)

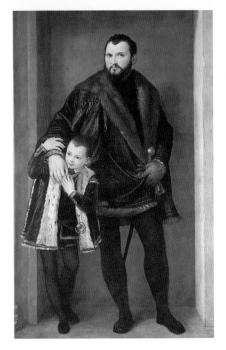

PAOLO VERONESE (1528–1588) The Count da Porto with His Son, 1550–60 Oil on canvas, $96\frac{1}{2} \times 52$ in. (247 × 133 cm)

GIOVANNI BATTISTA MORONI (c. 1529/30-1578) *The Count Pietro Secco Suardo*, 1563 Oil on canvas, 72 × 40½ in. (183 × 104 cm)

GIOVANNI BATTISTA MORONI (1529/30–1578) Giovanni Antonio Pantera, n.d. Oil on canvas, 31½ × 24½ in. (81 × 63 cm)

Alessandro Allori (1535–1607) The Satrifice of Isaac, 1601 Oil on wood, 3612×51 in. $(94 \times 131 \text{ cm})$

FEDERICO BAROCCI (1535–1612) Madonna of the People, 1575–79 Oil on wood, 140 \times 99 in. (359 \times 252 cm)

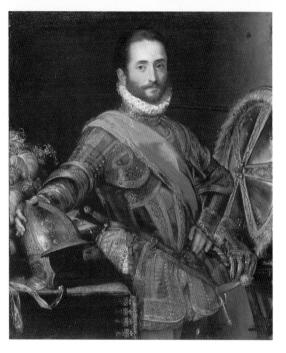

FEDERICO BAROCCI (1535–1612) Francesco II della Rovere, 1572 Oil on canvas, 44 × 36¼ in. (113 × 93 cm)

JACOPO ZUCCHI (1541?–1589/90) The Age of Gold, before 1587 Oil on wood, 19½ × 15½ in. (50 × 38.5 cm)

Empoli (Jacopo Chimenti) (1551–1646) Siill Life, 1624 Oil on canvas, $46\% \times 59\%$ in. (119 \times 152 cm)

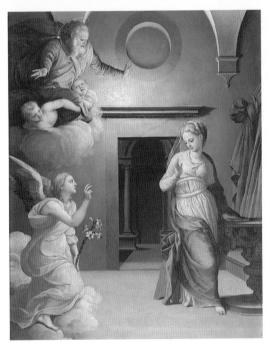

Giovanni Bizzelli (1556–1622) The Annunciation, n.d. Tempera on wood, $22\frac{1}{4} \times 17$ in. (57 \times 44 cm)

Annibale Carracci (1560–1609) Self-Portrait in Profile, 1590–1600 Oil on canvas, $17^{3/4} \times 14^{3/4}$ in. (45.5 \times 37.9 cm)

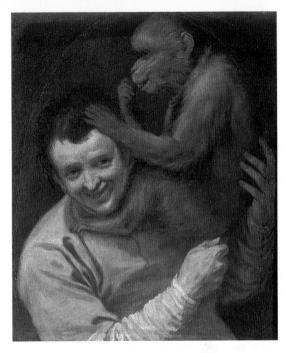

Annibale Carracci (1560–1609) *Man with a Monkey*, 1590–91

Oil on canvas, 26½ × 22¾ in. (68 × 58.3 cm)

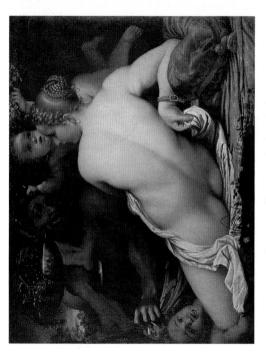

Annibale Carracci (1560–1609) Venus with Satyr and Cupids, 1588 Oil on canvas, $43\% \times 55\%$ in. (112 × 142 cm)

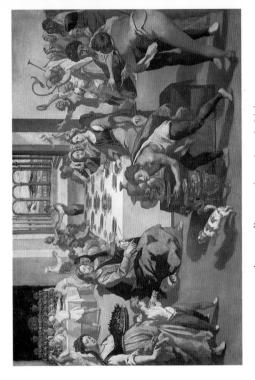

The Marriage at Cana, 1580/85Oil on canvas, $49\% \times 74\%$ in. $(127.5 \times 191 \text{ cm})$ Andrea Boscoli (c. 1560–1606/7)

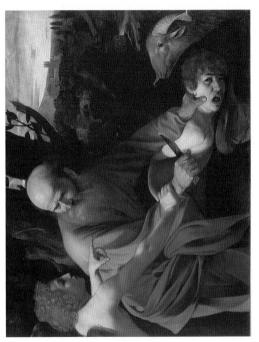

MICHELANGELO MERISI DA CARAVAGGIO (1570/71-1610) The Sarifice of Isaac, n.d. Oil on canvas, $40\frac{1}{2} \times 52\frac{1}{2}$ in. $(104 \times 135 \text{ cm})$

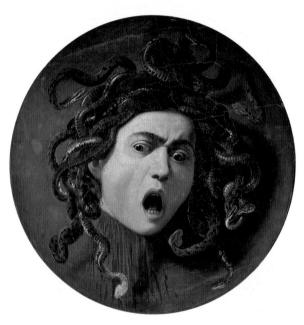

Michelangelo Merisi da Caravaggio (1570/71-1610) *Medusa*, after 1590 Oil on canvas mounted on wood, diameter: 21½ in. (55 cm)

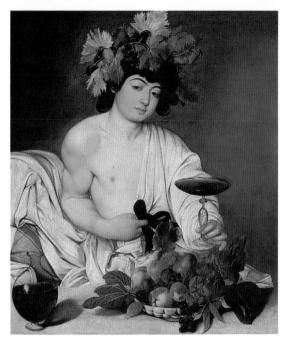

Michelangelo Merisi da Caravaggio (1570/71–1610) Young Bacchus, 1588–89 Oil on canvas, 37 \times 33 in. (95 \times 85 cm)

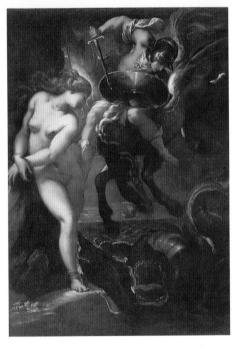

MORAZZONE (PIER FRANCESCO MAZZUCCHELLI) (1573–1626)

Perseus and Andromeda, c. 1610

Oil on canvas, 46½ × 36 in. (119 × 92.5 cm)

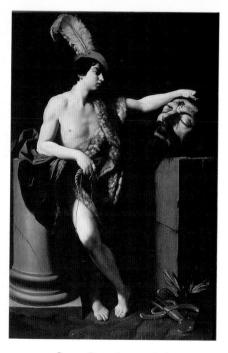

GUIDO RENI (1575–1642) David with the Head of Goliath, 1605 Oil on canvas, 86½ × 57½ in. (222 × 147 cm)

GUIDO RENI (1575–1642) *Madonna of the Snow,* c. 1625 Oil on canvas, 109 × 68½ in. (280 × 176 cm)

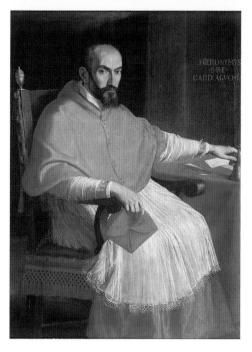

Domenichino (1581–1641) *Cardinal Aguechi*, 1605 Oil on canvas, 55% × 44% in. (142 × 112 cm)

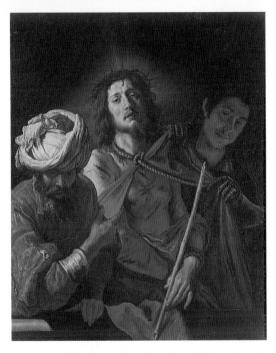

Domenico Feti (c. 1589–1625) Ecce Homo, 1600–1610 Oil on canvas, $53 \times 43\frac{1}{2}$ in. (136 × 112 cm)

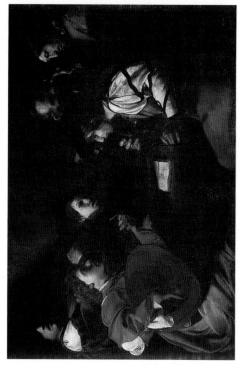

Вактосомео Манекері (с. 1587—1620/21) Concett, 1610-20 Oil on canvas, 50 \times 74 in. (130 \times 189.5 cm)

GIOVANNI DA SAN GIOVANNI (GIOVANNI MANNOZZI) (1590–1636) Apollo and Phaëthon, c. 1635 Fresco on rush matting, diameter: 24 in. (62 cm)

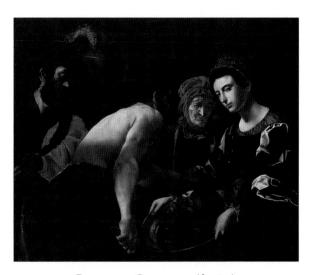

Battistello Caracciolo (d. 1637) Salome, c. 1615–20 Oil on canvas, $51\frac{1}{2} \times 61$ in. (132 × 156 cm)

GUERCINO (1591–1666) Summer Diversions, с. 1617 Oil on copper, 13¼ × 18 in. (34 × 46 сm)

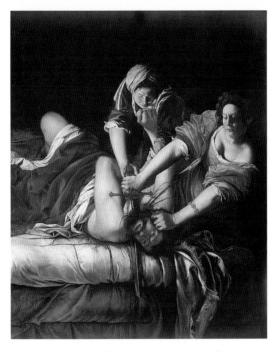

ARTEMISIA GENTILESCHI (1593–1652) Judith and Holofernes, c. 1620 Oil on canvas, $77\frac{1}{2} \times 63$ in. (199 \times 162.5 cm)

GIOVANNI BENEDETTO CASTIGLIONE (1610?-1670) $\label{eq:Circe, c. 1653} \textit{Circe, c. 1653}$ Oil on canvas, $71\times83\%$ in. $(182\times214~\text{cm})$

VIVIANO CODAZZI (1604–1670) Architectural View, c. 1627 Oil on canvas, $28\% \times 38\%$ in. $(73 \times 98$ cm)

GIROLAMO FORABOSCO (1604–1679)

Portrait of a Courtesan, c. 1665

Oil on canvas, 261/8 × 201/8 in. (66.5 × 53 cm)

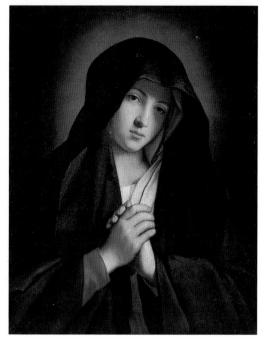

Sassoferrato (Giovanni Battista Salvi) (1609–1685) Our Lady of Sorrows, 1680–85 Oil on canvas, $24 \times 22\frac{1}{2}$ in. (62 \times 58 cm)

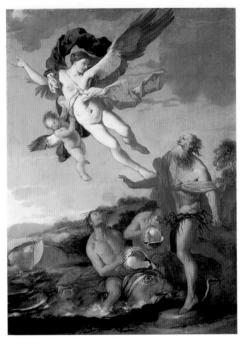

GIULIO CARPIONI (1613–1679) Neptune Chasing Coronis, 1665/70 Oil on canvas, $26 \times 19 \frac{1}{2}$ in. (67 × 50 cm)

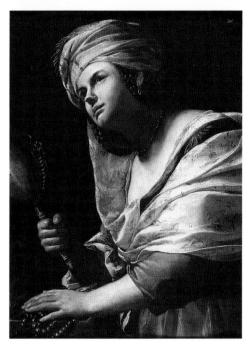

Mattia Preti (1613–1699) Vanity, c. 1650–70 Oil on canvas, $36\frac{1}{2} \times 25\frac{5}{8}$ in. (93.5 \times 65 cm)

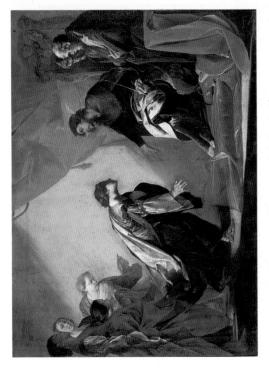

Bernardo Cavallino (1616–1656?) Esther and Ahasuerus, 1645–50 Oil on canvas, $29^{1/5} \times 39^{3/4}$ in. (76 × 102 cm)

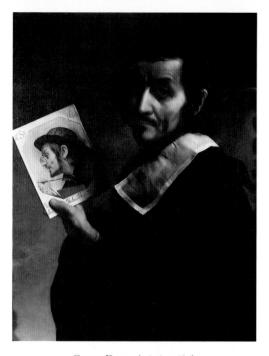

Carlo Dolci (1616–1686) Self-Portrait, 1674 Oil on canvas, 29 × 23½ in. (74.5 × 60.5 cm)

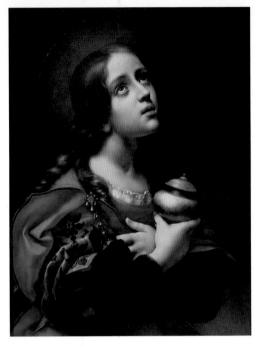

Carlo Dolci (1616–1686) *Magdalene*, 1660/70 Oil on canvas, 28½ × 22 in. (73.5 × 56.5 cm)

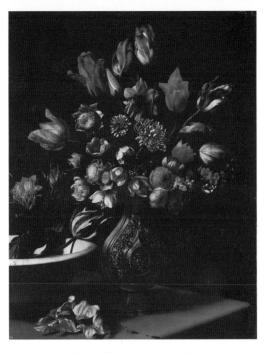

Carlo Dolci (1616–1686) Flowers, 1665/75 Oil on canvas, $27 \times 21 \frac{1}{2}$ in. (70 \times 55 cm)

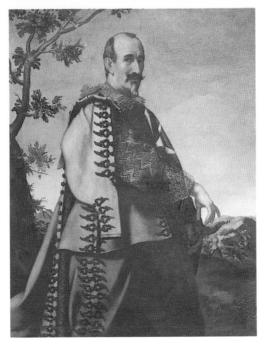

Carlo Dolci (1616–1686) *Ainolfo de' Bardi*, 1632 Oil on canvas, 58½ × 46½ in. (149.5 × 119 cm)

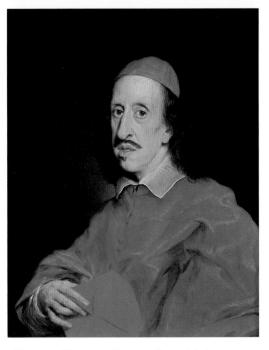

BACICCIO (GIOVANNI BATTISTA GAULLI) (1639–1709) Cardinal Leopoldo de' Medici, c. 1667 Oil on canvas, 28½ × 23 in. (73 × 60 cm)

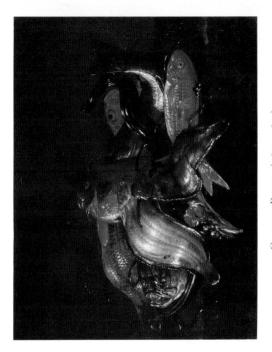

GIUSEPPE RECCO (1634-1695) Still Life with Fish, 1691Oil on canvas, $49\% \times 59\%$ in. $(127 \times 153 \text{ cm})$

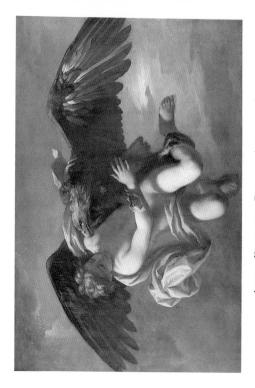

Anton Domenico Gabbiani (1652–1726) The Rape of Ganymede, 1700 Oil on canvas, $48\times67\%$ in. $(123\times173~{\rm cm})$

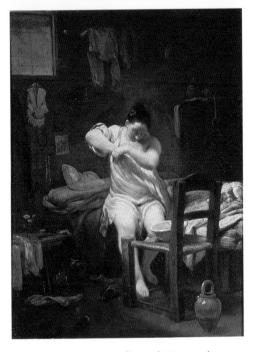

Giuseppe Maria Crespi (1665–1747) The Flea, 1710–30 Oil on copper, 18 \times 13 $^{1}\!\!/4$ in. (46.3 \times 34 cm)

GIUSEPPE MARIA CRESPI (1665–1747) The Fair at Poggio a Caiano, 1709 Oil on canvas, $45\% \times 76\%$ in. (116.7 \times 196.3 cm)

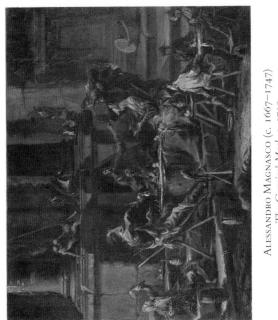

Alessandro Magnasco (c. 1667–1747) The Gypsies' Medl, c. 1710 Oil on canvas, 22×28 in. $(56 \times 71 \text{ cm})$

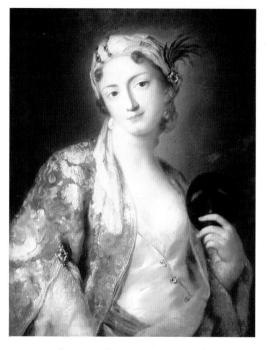

Rosalba Carriera (1675–1757) Felicità Sartori(?), 1730–40 Pastel on canvas, $27 \times 21\frac{1}{2}$ in. (70×55 cm)

GIOVANNI BATTISTA PIAZZETTA (1682–1754) Susanna and the Elders, before 1720 Oil on canvas, $39 \times 52\%$ in. (100 \times 135 cm)

GIOVANNI DOMENICO FERRETTI (1692–1747) The Rape of Europa, 1720–40 Oil on canvas, $57\% \times 80$ in. (147 \times 205 cm)

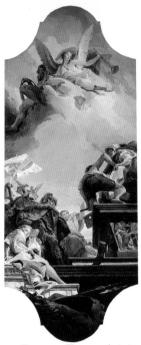

GIOVANNI BATTISTA TIEPOLO (1696–1770) Erection of a Statue to an Emperor, c. 1730 Oil on canvas, 13 ft. 7 in.× 5 ft. 8½ in. (4.20 × 1.75 m.)

GIOVANNI BATTISTA TIEPOLO (1696-1770) Rinaldo Abandons Armida, 1750-55 Oil on canvas, $27 \times 51 \%$ in. $(70 \times 132 \text{ cm})$

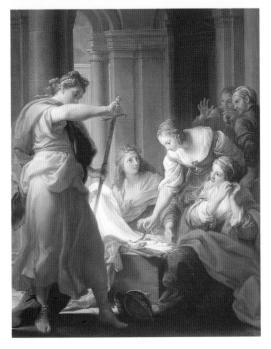

Pompeo Batoni (1708–1787) Achilles at the Court of Lycomedes, 1745 Oil on canvas, 62×49 in. (158.5 \times 126.5 cm)

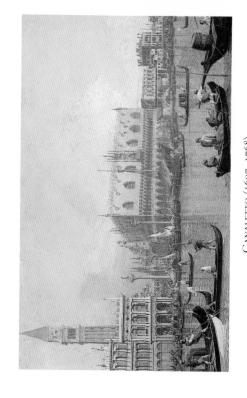

CANALETTO (1697–1768) The Ducal Palace and Piazza San Marco, before 1755 Oil on canvas, 20×32 in. $(51 \times 83$ cm)

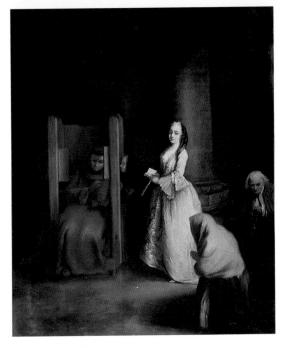

PIETRO LONGHI (1702–1785) The Confession, c. 1755 Oil on canvas, $23\frac{3}{4} \times 19$ in. (61 \times 49.5 cm)

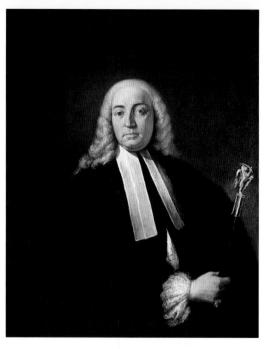

ALESSANDRO LONGHI (1733–1813) Portrait of a Magistrate, 1780–1800 Oil on canvas, $37^{3/4} \times 30^{1/2}$ in. (97 × 78 cm)

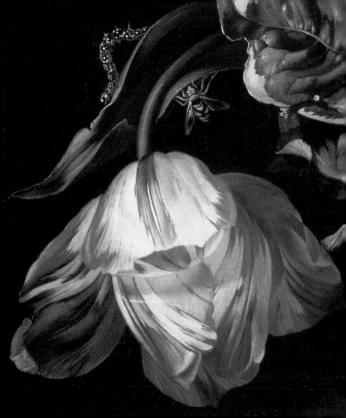

The museum has a particularly rich collection from the Dutch, Flemish, and German schools. From the fifteenth century on, Flemish artists in particular were skilled in representing nature and humanity, not subordinating them to any rational principle or intellectual theory but rather employing acute observation in the precise rendering of details—the physical qualities of fabrics, plants, landscapes, and human expressions. The presence of so many Flemish works in Florence indicates their importance to the history of Italian painting, just as northern European artists were influenced by contact with Italian art. An outstanding example of this reciprocal relationship is the great Portinari Altarpiece by Hugo van der Goes (pages 262-264), in which the flanking figures in the Adoration of the Shepherds are portraits of members of the Florentine Portinari family, who commissioned the work in Bruges. The Portinari were in that city to handle the business interests of the Medici, and when they brought the work home to Florence in 1483 it influenced local painters such as Domenico Ghirlandaio. An example of influence in the opposite direction is The Entombment (page 258), painted by Roger van der Weyden in Italy in 1450, which clearly indicates that the Flemish master was familiar with the balanced compositions of contemporary

Italian painting. Italian influence is also evident in *The Adoration of the Magi* (page 277), by the German Albrecht Dürer, who also traveled in Italy.

Dürer's beautiful *Portrait of the Artist's Father* (page 279), at once straightforward and affectionate, is displayed together with the more traditional but equally significant portraits by Lucas Cranach, in particular those of Martin Luther and his wife. Cranach's lively and graceful *Adam* and *Eve* (pages 280–281) must be compared with Hans Baldung Grien's more fluid *Adam* and *Eve* (pages 286–287): the almost classical proportions of the figures in the latter were based on Dürer.

Hans Memling, whose works had great influence on portrait painting in Tuscany during the fifteenth century, is well represented in the collection. His portraits are characterized by the severe black clothes of his sitters, who are shown half-length, and by the landscape views in the backgrounds.

The seventeenth century was a period of great variety and complexity for European painting, and the Uffizi collection from this period is extensive. During this century the members of the Medici family, from the grand dukes (Cosimo II, Ferdinando II, Cosimo III) to the princes and cardinals, closely followed developments in national and international art and acquired works by the leading artists of each period. Some paintings entered the family collection as gifts or were bought directly in

foreign lands, such as the Dutch paintings of which Cosimo III was so fond.

A room in the Uffizi is dedicated to Peter Paul Rubens, who began a close relationship with the Medici during a stay in Italy. In Florence in 1600 he participated in the wedding by proxy of Maria de' Medici to King Henry IV of France. Years later Maria, as queen of France, commissioned him to make an imposing series of large allegorical paintings showing the important events of her life; she later asked for a similar series based on the life of Henry IV. The series was never completed, but two unfinished works in the Uffizi are currently being restored after damage sustained in the May 1993 bombing. Their large size (more than twenty-two feet wide) permitted Rubens, the leading representative of the European Baroque movement, to give full vent to his theatrical and explosive tendencies, using robust and vibrant colors and animated technique. Alongside these official subjects is his portrait of his wife, Isabella Brandt (page 271), which shows how Rubens could direct his talents to other subjects; sensuous affection and playful intimacy run through this warm image of a youthful and vivacious woman. Together with the exuberant works by Rubens are examples of the more reserved and official portraits made by his great pupil Anthony Van Dyck.

The Uffizi's collection of seventeenth-century Dutch painting is rich and varied, but at the moment the museum can display only a small portion of it. There are impressive and moving self-portraits by Rembrandt, and the walls of an entire room are covered with small paintings of various subjects, works of which Cosimo III de' Medici was a passionate collector. Genre scenes painted by Frans van Mieris and Caspar Netscher are displayed together with views by Gerrit Berckheyde and Jacob Ruysdael, and there are also still lifes by Rachel Ruysch and Jan van Huysum. Taken together these works offer a complete panorama of the varied pictorial universe of flourishing bourgeois Holland.

Dutch Painting

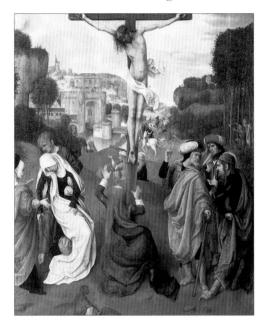

Master of the Virgo inter Virgines (active c. 1460-1520) The Crucifixion, n.d. Oil on wood, $22\frac{1}{4} \times 18\frac{1}{4}$ in. $(57 \times 47 \text{ cm})$

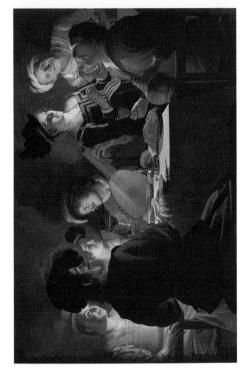

Gerrit van Honthorst (1590–1656) Supper with Lute Player, c. 1617 Oil on canvas, 54×79 in. (138 \times 203 cm)

Oil on canvas mounted on wood, $21\frac{1}{2} \times 38\frac{1}{2}$ in. (55 × 99 cm) Landscape, 1620-30

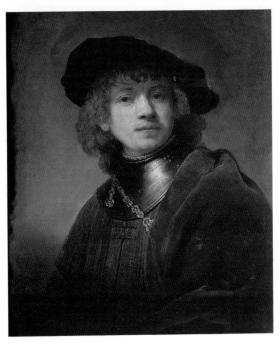

REMBRANDT VAN RIJN (1606–1669) Self-Portrait as a Young Man, 1634 Oil on canvas, 24½ × 21 in. (62.5 × 54 cm)

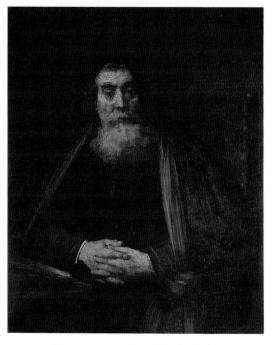

REMBRANDT VAN RIJN (1606-1669)

Portrait of an Old Man, 1665

Oil on canvas, 40½ × 33½ in. (104 × 86 cm)

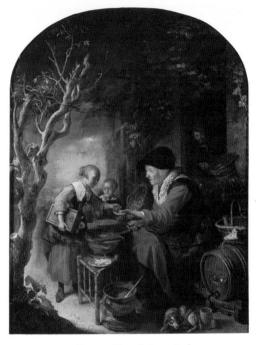

Gerard Dou (1613-1675) *Pancake Seller,* 1650-55

Oil on wood, 17 × 13¹/₄ in. (44 × 34 cm)

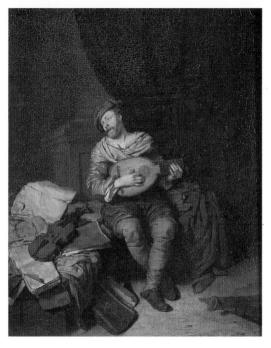

Cornelis Bega (1631/32-1664) Guitar Player, 1664 Oil on wood, $14 \times 12\frac{1}{2}$ in. (36 × 32 cm)

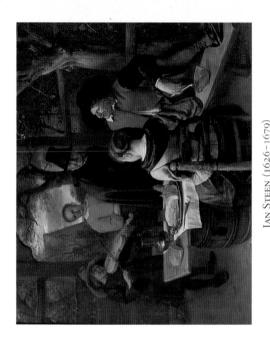

JAN STEEN (1626–1679)

The Luncheon, 1650–60

Oil on wood, 16 × 19½ in. (41 × 49.5 cm)

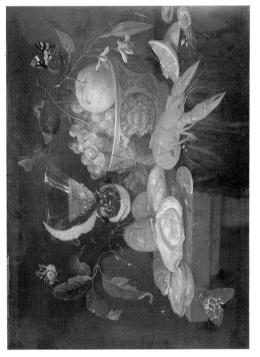

Jan Van Kessel (1626-1679) Still Life with Fruit and Shellfish, 1653 Oil on canvas, 12 \times 17 in. (31 \times 44 cm)

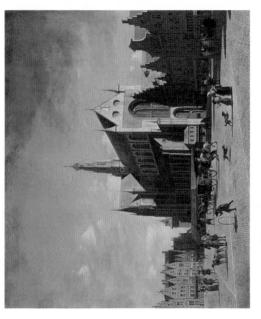

Gerrit Berckheyde (1638–1698) The Market at Haarlem, 1693 Oil on canvas, 21×25 in. $(54 \times 64$ cm)

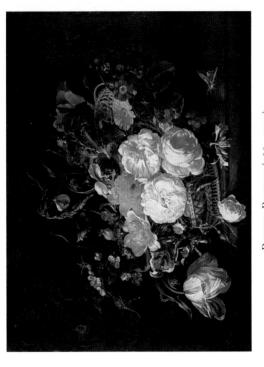

Rachel Ruysch (1664–1750) Flowers and Insects, 1711 Oil on wood, 17 \times 25% in. (44 \times 66 cm)

Flemish Painting

Roger van der Weyden (c. 1400–1464) The Entombment, 1450 Oil on wood, $43 \times 37^{3/4}$ in. (110 \times 96 cm)

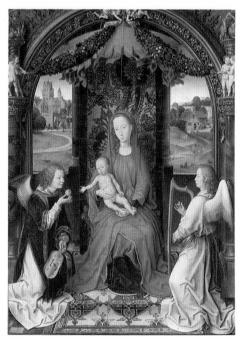

HANS MEMLING (c. 1430/40-1494) Madonna and Child Enthroned with Two Angels, c. 1480Oil on wood, $22^{1/4} \times 16^{1/2}$ in. $(57 \times 42 \text{ cm})$

Hans Memling (c. 1430/40-1494) Benedetto di Tommaso Portinari, 1487 Oil on wood, $17\frac{1}{2} \times 13\frac{1}{4}$ in. (45 \times 34 cm)

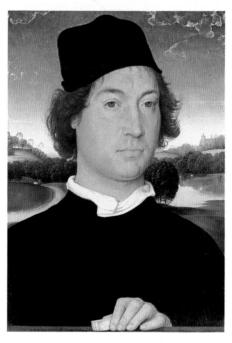

HANS MEMLING (c. 1430/40-1494) Portrait of an Unknown Man, 1490 Oil on wood, $13\frac{1}{2} \times 9\frac{3}{4}$ in. $(35 \times 25$ cm)

Hugo van der Goes (c. 1440-1482) Left panel of *Portinari Altarpiece*, c. 1475 (See page 264.)

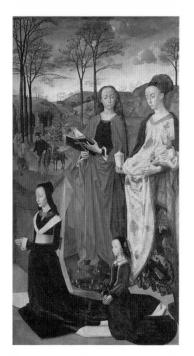

Hugo van der Goes (c. 1440-1482) Right panel of *Portinari Altarpiece*, c. 1475 (See page 264.)

Dutch Painting

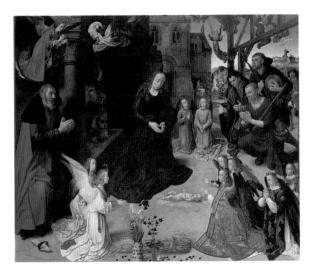

Hugo van der Goes (c. 1440-1482) Central panel of Portinari Altarpiece (The Adoration of the Shepherds), c. 1475 Oil on wood, 8 ft. 2½ in. × 18 ft. 5 in. (2.53 × 5.68 m.) overall

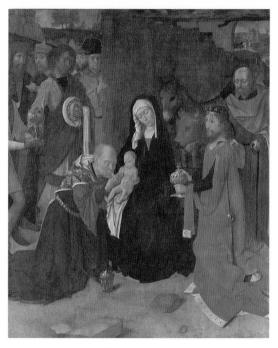

Gerard David (c. 1460-1523) The Adoration of the Magi, c. 1490 Watercolor on canvas, 37×31 in. $(95 \times 80$ cm)

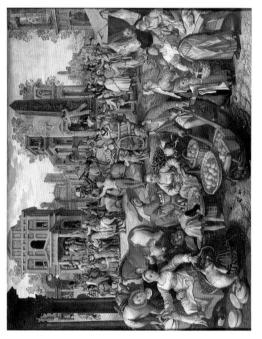

JOACHIM BEUCKELAER (c. 1530–c. 1574) Pilate Shows Christ to the People, 1566 Oil on wood, 43×58 in. (110 \times 149 cm)

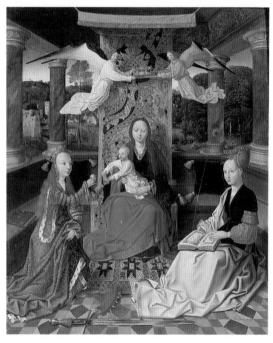

MASTER OF HOOGSTRAETEN (active c. 1490-1530)

Madonna Enthroned with Saints Catherine and Barbara, c. 1500

Oil on wood, 32¾ × 27 in. (84 × 70 cm)

Joos van Cleve (c. 1485–1540) Portrait of an Unknown Man, c. 1520 Oil on wood, $22^{1/4} \times 16^{1/2}$ in. (57 × 42 cm)

Joos van Cleve (c. 1485-1540) Portrait of an Unknown Woman, c. 1520 Oil on wood, 22¹/₄ × 16¹/₂ in. (57 × 42 cm)

Peter Paul Rubens (1577–1640) $Self ext{-}Portrait$, 1628 Oil on canvas, $30\frac{1}{2} \times 23\frac{3}{4}$ in. (78 × 61 cm)

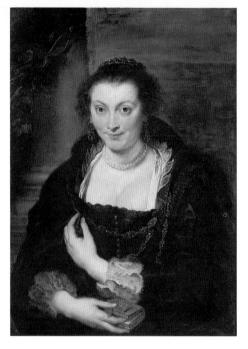

Peter Paul Rubens (1577–1640) Isabella Brandt, c. 1625–26 Oil on canvas, $33\frac{1}{2} \times 24$ in. $(86 \times 62$ cm)

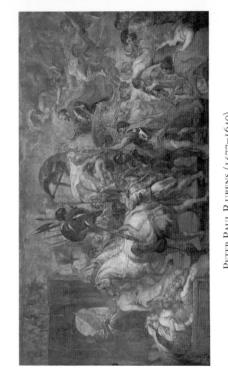

PETER PAUL R. UBENS (1577–1640)

Triumphal Entry of Henry IV into Paris, n.d.

Oil on canvas, 12 ft. 4 in. \times 22 ft. 6 in. (3.80 \times 6.92 m.)

DAVID TENIERS (1610—1690) Interior of a Cottage, c. 1640 Oil on wood, 25×34 in. $(64 \times 87 \text{ cm})$

Oil on wood, $22\% \times 36\%$ in. $(57 \times 94 \text{ cm})$ Jan Breughel the Younger (1601–1678) Allegory of Air and Fire, 1650-60

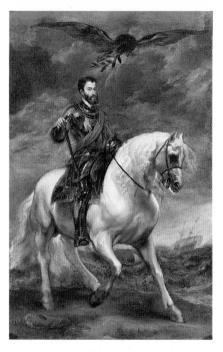

Anthony van Dyck (1599–1641) *Emperor Charles V,* c. 1620 Oil on canvas, 74½ × 48 in. (191 × 123 cm)

Anthony van Dyck (1599–1641) *Jean de Monfort, c.* 1628

Oil on canvas, 48 × 33½ in. (123 × 86 cm)

German Painting

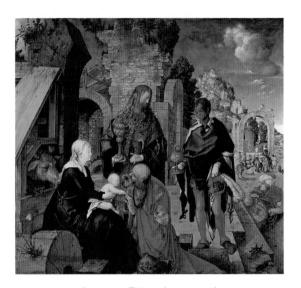

Albrecht Dürer (1471–1528) The Adoration of the Magi, 1504 Oil on wood, $38\frac{1}{2} \times 44\frac{1}{4}$ in. (99 × 113.5 cm)

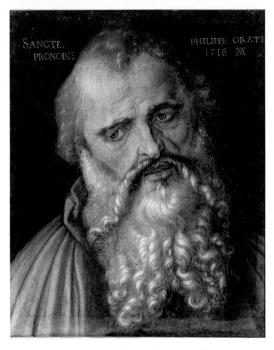

Albrecht Dürer (1471–1528) Saint Philip the Apostle, 1516 Tempera on canvas, $17\frac{1}{2} \times 15$ in. (45 \times 38 cm)

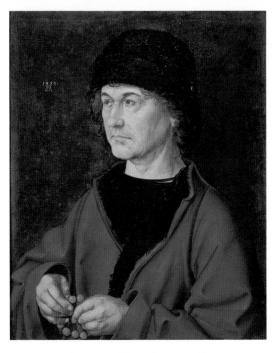

Albrecht Dürer (1471–1528)

Portrait of the Artist's Father, 1490

Oil on wood, 18½ × 15½ in. (47.5 × 39.5 cm)

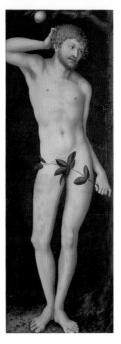

Lucas Cranach the Elder (1472–1553) Adam, 1528 Oil on wood, 67 × 24½ in. (172 × 63 cm)

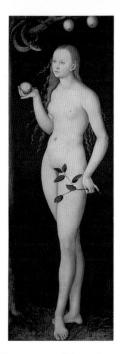

Lucas Cranach the Elder (1472–1553) $Eve, \ 1528$ Oil on wood, $67 \times 24 \frac{1}{2}$ in. (172 \times 63 cm)

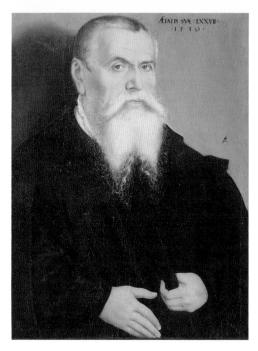

Lucas Cranach the Younger (1515–1586) Lucas Cranach the Elder, 1550 Oil on wood, 25 × 19 in. (64 × 49 cm)

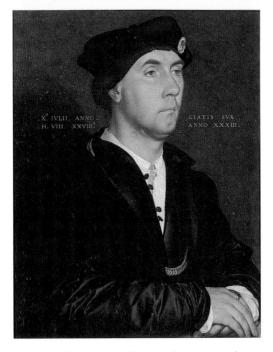

Hans Holbein the Younger (c. 1497–1543) Sir Richard Southwell, 1536 Oil on wood, 18½ × 15 in. (47.5 × 38 cm)

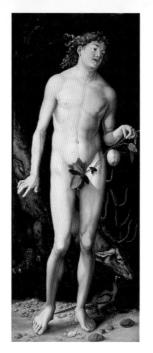

Hans Baldung Grien (c. 1484–1545) *Adam* (after Dürer), c. 1507 Oil on wood, 82½ × 33 in. (212 × 85 cm)

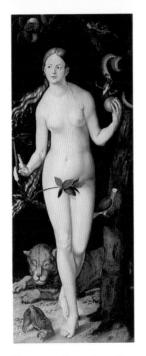

Hans Baldung Grien (c. 1484–1545) *Eve* (after Dürer), c. 1507 Oil on wood, 82½ × 33 in. (212 × 85 cm)

ALBRECHT ALTDORFER (1480–1538) The Departure of Saint Florian, c. 1520 Oil on wood, $31\frac{3}{4} \times 26$ in. (81.4 × 67 cm)

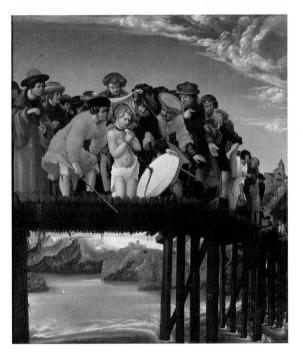

ALBRECHT ALTDORFER (1480–1538) The Martyrdom of Saint Florian, c. 1520 Oil on wood, $29\frac{3}{4} \times 26\frac{3}{4}$ in. (76.4 × 67.2 cm)

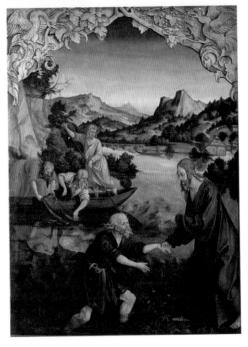

Hans von Kulmbach (c. 1480–1522) *The Calling of Saint Peter,* 1514–16 Oil on wood, 50% × 37½ in. (128.5 × 95.5 cm)

HANS VON KULMBACH (c. 1480–1522)

The Sermon of Saint Peter, 1514–16

Oil on wood, 511/8 × 371/4 in. (130 × 95.5 cm)

FRENCH AND SWISS PAINTING

Grand duke Ferdinando III (1769–1824) expanded the Uffizi's collection of French art, acquiring older works in an attempt to match the breadth of the Uffizi's holdings of Italian and Northern art. He also repeatedly sent agents to France to purchase contemporary paintings. As a result, the galleries house an extraordinary selection of French painting from the seventeenth and eighteenth centuries.

Simon Vouet's Annunciation (page 295), bought in Paris, shows the influence of Caravaggio. The fashion for classical landscapes was best represented in Italy by two French painters, Claude Lorrain and Nicolas Poussin. In Claude's Port with Villa Medici (page 297), a "portrait" of the Medici palace in Rome is combined with a fantastic and evocative seaside sunset. Jean-Baptiste-Siméon Chardin's Girl with Racket and Shuttlecock (page 300) and Boy Playing with Cards (page 301), both ordinary scenes rendered in limpid and luminous tones, give a sense of the heights reached by French artists during the eighteenth century. Elegant official portraits of royal subjects, by Jean-Marc Nattier and others, are contrasted with the astonishingly modern paintings by the Swiss Jean-Etienne Liotard, whose refined Marie-Adelaide of France in Turkish Dress (page 303), with its glimpse of a young woman absorbed in her reading, anticipates the intimate tone of nineteenth-century works.

291

French Painting

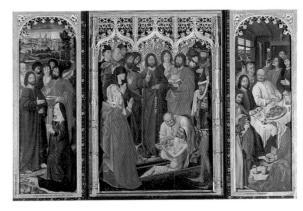

NICOLAS FROMENT (C. 1435–1483) The Resurrection of Lazarus, 1461 Tempera on wood, $68\% \times 78$ in. (175 \times 200 cm) overall

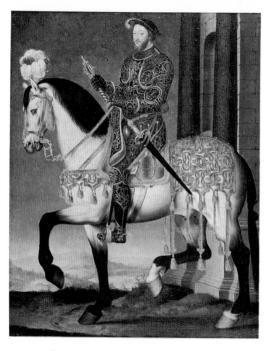

François Clouet (c. 1510–c. 1572) *Francis I of France*, c. 1540 Oil on wood, 10¾ x 8¾ in. (27.5 x 22.5 cm)

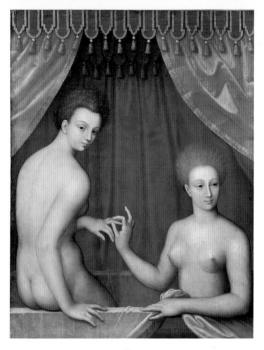

School of Fontainebleau Gabrielle d'Estrées with a Sister, c. 1590 Oil on wood, 50¾ × 38 in. (129 × 97 cm)

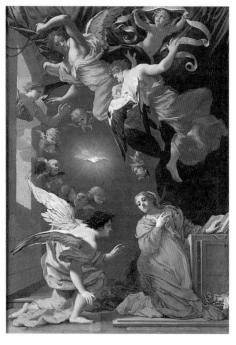

Simon Vouet (1590–1649) The Annunciation, n.d. Oil on canvas, $47 \times 33 \%$ in. (120.5 \times 86 cm)

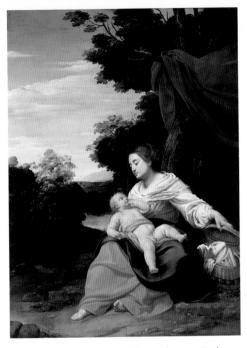

Attributed to SIMON VOUET (1590-1649) *Madonna of the Basket*, 1625-26

Oil on wood, 51½ × 38¼ in. (132 × 98 cm)

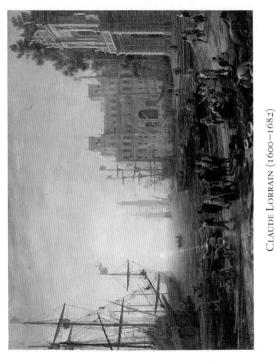

Oil on canvas, 39% × 52 in. (102 × 133 cm)

JEAN JOUVENET (1644–1717)

The Education of the Virgin, 1700

Oil on canvas, $39^{34} \times 27^{1/2}$ in. (102 × 71 cm)

François Boucher (1703–1770) Christ and John the Baptist as Children, 1758 Oil on oval canvas, $19\frac{1}{2} \times 17$ in. (50 \times 44 cm)

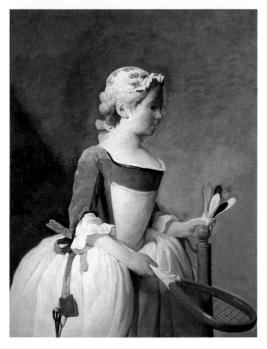

JEAN-BAPTISTE-SIMÉON CHARDIN (1699–1779) Girl with Racket and Shuttlecock, c. 1740 Oil on canvas, $32 \times 25\%$ in. $(82 \times 66 \text{ cm})$

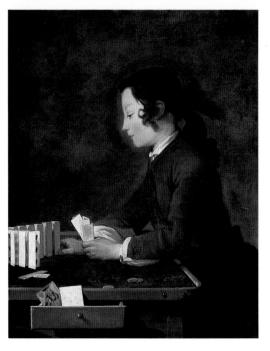

Jean-Baptiste-Siméon Chardin (1699–1779) Boy Playing with Cards, c. 1740 Oil on canvas, $32 \times 25^{3/4}$ in. $(82 \times 66 \text{ cm})$

Swiss Painting

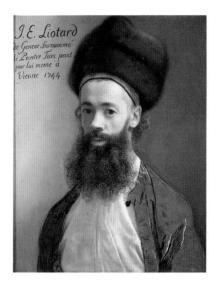

Jean-Etienne Liotard (1702–1789) Self-Portrait, 1744 Pastel on paper, $23\%4 \times 19$ in. (61 × 49 cm)

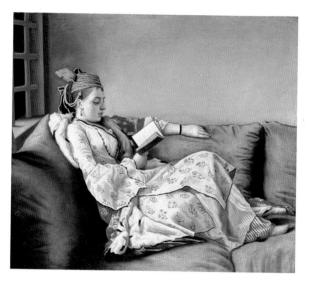

JEAN-ETIENNE LIOTARD (1702–1789) Marie-Adelaide of France in Turkish Dress, 1753 Oil on canvas, $19\frac{1}{2} \times 22$ in. (50 × 56 cm)

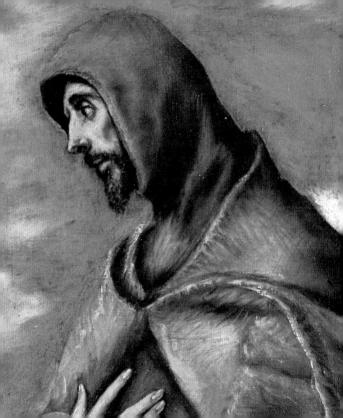

SPANISH PAINTING

It was not until late in this century that Spanish works of major importance entered the Uffizi collection. Paintings by Francisco de Goya are on display thanks to two relatively recent important acquisitions, including *Maria Theresa of Vallabriga on Horseback* (page 311), with its unusual and powerful color combinations, and *The Countess of Chinchon* (page 312), remarkable for both the delicate and respectful psychological study and the masterful technique used to render the pearly dress and feathered headdress. Another important acquisition of the 1970s was a painting by El Greco, *Saints John the Evangelist and Francis* (page 307).

The Contini Bonacossi donation came to the Uffizi in 1974, bringing a version of the celebrated Water Carrier of Seville by Velázquez (page 309) to complement two works by Velázquez in the self-portrait collection—one of which entered the collection as early as 1690. The Contini Bonacossi donation also includes a Torero attributed to Goya; The Tears of Saint Peter, a splendid work by El Greco; and Saint Anthony Abbot by Francisco de

Zurbarán (page 310).

Alonso Berruguete (1488–1561) $Salome, \ 1512/16$ Tempera on wood, 34 \times 27½ in. (87.5 \times 71 cm)

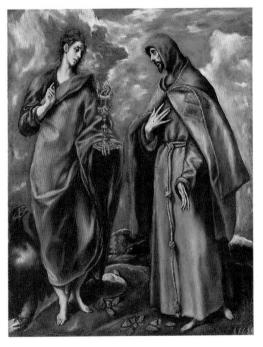

EL GRECO (1541–1614) Saints John the Evangelist and Francis, c. 1600 Oil on canvas, 43 x 33½ in. (110 x 86 cm)

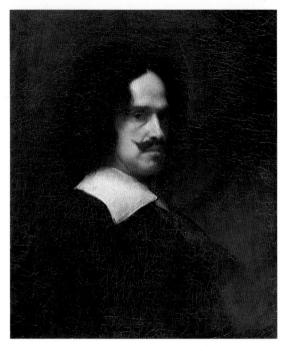

Diego Velázquez (1599–1660) *Self-Portrait*, c. 1643 Oil on canvas, 40¼ × 32 in. (103.5 × 82.5 cm)

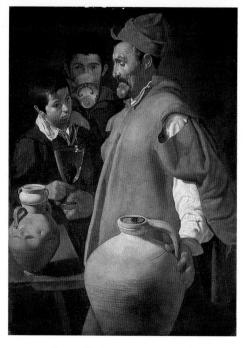

DIEGO VELÁZQUEZ (1599–1660) The Water Carrier of Seville, c. 1620 Oil on canvas, $40\frac{1}{2} \times 29\frac{1}{4}$ in. (104 × 75 cm)

Francisco de Zurbarán (1598–1664) Saint Anthony Abbot, c. 1640 Oil on canvas, $69 \times 45\frac{1}{2}$ in. (177 × 117 cm)

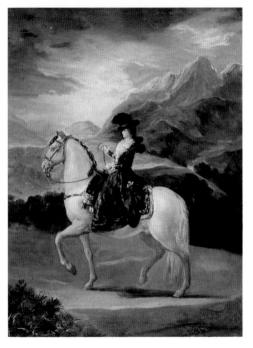

Francisco de Goya (1746–1828) Maria Theresa of Vallabriga on Horseback, 1783 Oil on canvas, 32×24 in. $(82.5 \times 61.7 \text{ cm})$

Francisco de Goya (1746–1828) The Countess of Chinchon, c. 1801 Oil on canvas, 86×55 in. (220 \times 140 cm)

INDEX OF ILLUSTRATIONS

Achilles at the Court of Lycomedes (Batoni), 238 Adam (Cranach the Elder). 280 Adam (Grien), 284 Adoration of the Child. The (Correggio), 155 Adoration of the Child, The (Filippino Lippi), 106 Adoration of the Child, The (Fra Filippo Lippi), 59 Adoration of the Child. The (Mazzolino), 130 Adoration of the Magi, The (Botticelli), 85 Adoration of the Magi, The (David), 265 Adoration of the Magi. The (Dürer), 277 Adoration of the Magi, The (Gentile da Fabriano), 45 Adoration of the Magi, The (Ghirlandaio), 100 Adoration of the Magi. The (Leonardo), 104 Adoration of the Magi, The (Filippino Lippi), 109 Adoration of the Shepherds, The (from Portinari Altarpiece) (Goes), 264 Age of Gold, The (Zucchi), 106 Ainolfo de' Bardi (Dolci), 226 Albertinelli, Mariotto, 122 Allegory of Air and Fire (J. Breughel the Younger), 274 Allori, Alessandro, 193 Altarpiece with Redeemer and Saints Peter, Mary, John the Evangelist, and Paul

(Meliore di Jacopo), 27

Altdorfer, Albrecht, 286, 287 Angelico, Fra. 57 Annunciation, The (Baldovinetti), 69 Annunciation. The (Bizzelli). Annunciation, The (Credi), Annunciation, The (Leonardo), 103 Annunciation. The (Veronese), 188 Annunciation, The (Vouet), Annunciation and Two Saints, The (Martini and Memmi). 36 Apollo and Phaëthon (Giovanni da San Giovanni), 212 Appearance of the Virgin to Saint Bernard, The (Bartolomeo), 121 Architectural View (Codazzi), Ascension, The Adoration of the Magi, and The Circumcision, The (Mantegna), 74 Baciccio (Giovanni Battista Gaulli), 227 Baldovinetti, Alessio, 69 Baptism of Christ, The (Verrocchio and Leonardo), 102 Barocci, Federico, 194, 195 Bartolomeo, Fra. 121 Bartolomeo Panciatichi (Bronzino), 174 Bassano, Jacopo, 183, 184 Batoni, Pompeo, 238 Battle of San Romano, The (Uccello), 54-55

Beccafumi, Domenico, 158 Bega, Cornelis, 253 Bellini, Giovanni, 70 Bellini, Jacopo, 50 Benedetto di Tommaso Portinari (Memling), 260 Berckheyde, Gerrit, 256 Berruguete, Alonso, 306 Beuckelaer, Joachim, 266 Bia. Illegitimate Daughter of Cosimo I de' Medici (Bronzino), 170 Biondo, Giovanni del, 41 Birth of John the Baptist. The (Pontormo), 165 Birth of Saint Nicholas. The (P. Veneziano), 48 Birth of Venus, The (Botticelli), 90, 91 Bizzelli, Giovanni, 198 Boltraffio, Giovanni Antonio, 118 Boscoli, Andrea, 202 Botticelli, Sandro, 82-93 Boucher, François, 299 Boy Playing with Cards (Chardin), 301 Bramantino, 117 Breughel, Jan, the Younger, 274 Bronzino, 170-75 Bugiardini, Giuliano, 126 Calling of Saint Peter, The (Kulmbach), 288 Campi, Giulio, 169 Canaletto, 239 Caracciolo, Battistello, Caravaggio, Michelangelo

Merisi da, 203-5

(Domenichino), 209

Cardinal Aoucchi

Cardinal Leonoldo de' Medici (Baciccio), 227 Carpaccio, Vittore, 119 Carpioni, Giulio, 220 Carracci, Annibale, 199-201 Carriera, Rosalba, 233 Castagno, Andrea del. 66-68 Castiglione, Giovanni Benedetto, 216 Catena, Vincenzo di Biagio, Cavallino, Bernardo, 222 Chardin, Jean-Baptiste-Siméon, 300, 301 Charity (P. Pollaiolo), 80 Charity (Salviati), 178 Charity of Saint Nicholas, The (P. Veneziano), 49 Chimenti, Jacopo (Empoli), Christ and John the Baptist as Children (Boucher), 299 Cimabue, 28 Cima da Conegliano. Giovanni Battista, 116 Cione, Iacopo di, 30 Circe (Castiglione), 216 Claude Lorrain, 297 Cleve, Joos van, 268, 269 Clouet, François, 203 Codazzi, Viviano, 217 Concert (Manfredi), 211 Confession, The (P. Longhi), Coronation of the Virgin, The (Angelico), 57 Coronation of the Virgin, The (Botticelli), 93 Coronation of the Virgin, The (Fra Filippo Lippi), 60 Coronation of the Virgin, The (Lorenzo Monaco), 44

Cosimo the Elder (Pontormo). 162 Cosimo I de' Medici (Bronzino), 171 Costa, Lorenzo, 112, 113 Count da Porto with His Son. The (Veronese), 100 Countess of Chinchon, The (Goya), 312 Count Pietro Secco Suardo. The (Moroni), 191 Cranach, Lucas, the Elder, 280, 281 Cranach, Lucas, the Younger, 282 Credi, Lorenzo di, 110, 111 Crespi, Giuseppe Maria, 230, 231 Crucifixion. The (A. Gaddi). 43 Crucifixion. The (Master of the Virgo inter Virgines), 247 Crucifixion with Mary Magdalene, The (Signorelli), 98 Crucifix with Stories of the Passion (Master of the San Francesco Bardi), 25 Crucifix with Stories of the Passion (Pisan School), 24 Daddi, Bernardo, 37 Daniele da Volterra, 179 Dante Alighieri (Castagno), 68 David, Gerard, 265 David with the Head of Goliath (Reni), 207 Death of Adonis, The (Piombo), 145 Departure of Saint Florian, The (Altdorfer), 286 Discovery of the Body of Holofernes (Botticelli), 83 Dolci, Carlo, 223-26 Domenichino, 200

Doni Tondo. The (The Holy Family) (Michelangelo). Dosso Dossi, 156, 157 Dou, Gerard, 252 Ducal Palace and Piazza San Marco, The (Canaletto), 239 Duccio di Buoninsegna, 29 Duchess of Urbino, The (Piero della Francesca), 62; verso, 64 Duke of Urbino, The (Piero della Francesca), 63; verso, Dürer, Albrecht, 277-79 Dyck, Anthony van, 275, 276 Ecce Homo (Feti), 210 Education of the Virgin, The (Iouvenet), 298 Eleanor of Toledo with Her Son Giovanni de' Medici (Bronzino), 172 Elisabetta Gonzaga (Raphael), 143 Emperor Charles V (van Dyck), 275 Empoli (Jacopo Chimenti), Entombment, The (Weyden), Entry of Charles VIII into Florence (Granacci), 125 Erection of a Statue to an Emperor (Tiepolo), 236 Esther and Ahasuerus (Cavallino), 222 Evangelista Scappi (Francia), Eve (Cranach the Elder), 281 Eve (Grien), 285 Executioner with the Head of John the Baptist (Herodias)

(Luini), 114

Fair at Poggio a Caiano, The (Crespi), 231 Farinata degli Uberti (Castagno), 67 Felicità Sartori(?) (Carriera). Ferrari, Defendente, 160 Ferretti, Giovanni Domenico, 235 Feti. Domenico, 210 Flea. The (Crespi), 230 Flora (Titian), 151 Flowers (Dolci), 225 Flowers and Insects (Ruysch), 242, 257 Fontainebleau, School of, 200, 204 Foppa, Vincenzo, 71 Forabosco, Girolamo, 218 Four Saints from an Altarpiece (Sarto), 149 Four Saints of the Quaratesi Polyptych (Gentile da Fabriano), 46 Francesco delle Opere (Perugino), 95 Francesco II della Rovere (Barocci), 195 Francesco Maria della Rovere (Titian), 150 Francia, Francesco, 101 Franciabigio, 146 Francis I of France (Clouet), Froment, Nicolas, 292 Gabbiani, Anton Domenico, Cabrielle d'Estrées with a Sister (School of Fontainebleau), 290, 294 Gaddi, Agnolo, 43 Gaddi, Taddeo, 38 Galeazzo Maria Sforza (P. Pollaiolo), 79

Gaulli, Giovanni Battista (Baciccio), 227 Gentile da Fabriano, 45, 46 Gentileschi, Artemisia, 14. Ghirlandaio, Domenico, 99, Giorgione, 127, 128 Giottino, 40 Giotto, 30 Giovanni Antonio Pantera (Moroni), 192 Giovanni Bentivoglio (Costa), 112 Giovanni da Milano, 42 Giovanni da San Giovanni (Giovanni Mannozzi), 212 Girl with Racket and Shuttlecock (Chardin), 300 Goes, Hugo van der, 262-64 Gova. Francisco de, 311, 312 Granacci, Francesco, 124, Greco, El, 304, 307 Grien, Hans Baldung, 284, 285 Guercino, 214 Guidobaldo da Montefeltro (Raphael), 142 Guitar Player (Bega), 253 Gypsies' Meal, The (Magnasco), 232 Head of a Young Man (Lotto), Hercules and Antaeus (A. Pollaiolo), 76 Hercules and the Hydra (A. Pollaiolo), 77 Holbein, Hans, the Younger, Holy Family, The (The Doni Tondo) (Michelangelo), 123 Holy Family, The (Signorelli), 97

Holy Family and Saints, The (Vecchio), 135 Holy Family with Saint Barbara and Young Saint John, The (Veronese), 187 Holy Family with Young Saint John. The (Beccafumi), 158 Honthorst Gerrit van. 248 Hunting Dogs (Bassano), 183 Illustrious Men series (Castagno), 66-68 Interior of a Cottage (Teniers), Isabella Brandt (Rubens), 271 Iean de Monfort (van Dyck). Joseph Presents His Father and Brothers to the Pharaoh (Granacci), 124 Jouvenet, Jean, 298 Judgment of Solomon, The (Giorgione), 127 Iudith (Vecchio), 134 Judith and Holofernes (Gentileschi), 14, 215 Kessel, Jan van, 255 Kulmbach, Hans von, 288, 289 Lamentation over the Body of Christ, The (G. Bellini), 70 Landscape (Seghers), 249 Leda and the Swan (Tintoretto), 185 Leonardo da Vinci, 102-4 Liotard, Jean-Etienne, 302, 303 Lippi, Filippino, 106-9 Lippi, Fra Filippo, 2, 58-60 Longhi, Alessandro, 241 Longhi, Pietro, 240 Lorenzetti, Ambrogio, 33, 34 Lorenzetti, Pietro, 31, 32 Lorenzo da Sanseverino, 120 Lorenzo Monaco, 44

Lorenzo the Magnificent (Vasari), 181 Lotto, Lorenzo, 131-33 Lucas Cranach the Elder (Cranach the Younger). 282 Lucrezia Panciatichi (Bronzino), 175 Luini, Bernardino, 114 Luncheon, The (Steen), 254 Madonna and Child (I. Bellini), so Madonna and Child (Cima da Conegliano), 116 Madonna and Child (Ferrari). 160 Madonna and Child (Madonna of the Otto) (Filippino Lippi), 108 Madonna and Child (Mantegna), 72 Madonna and Child (Masaccio), 53 Madonna and Child (Romano), 159 Madonna and Child (Signorelli), 96 Madonna and Child and Young Saint John (Pontormo), 162 Madonna and Child Enthroned with Saints (Vecchietta), 61 Madonna and Child Enthroned with Two Angels (Memling), 250 Madonna and Child with Angel (Foppa), 71 Madonna and Child with Saint Anne (Masolino da Panicale and Masaccio) 52 Madonna and Child with Saint John the Baptist (Bassano), 316

184

Madonna and Child with Saints (Bramantino), 117 208 Madonna and Child with Saints (Lotto), 133 Madonna and Child with Saints (Rosso), 166 Madonna and Child with Saints (Magnoli Altarpiece) (D. Veneziano), s6 Madonna and Child with Two Angels (Fra Filippo Lippi). 2.58 Madonna and Child with Young Saint John (Madonna del Cardellino) (Raphael). 140 Madonna Enthroned with Angels (P. Lorenzetti). 31 Madonna Enthroned (Maestà) with Angels and Four Prophets (Cimabue), 28 Madonna Enthroned with Saints (Ghirlandaio), 99 Madonna Enthroned with Saints Catherine and Barbara (Master of Hoogstraeten), 267 Madonna in Glory (T. Gaddi). Madonna in Glory (Giotto), 30 Madonna of Humility (Masolino da Panicale), 51 Madonna of Saint Zachariah (Parmigianino), 176 Madonna of the Basket (Vouet), 296 Madonna of the Harpies (Sarto), 148 Madonna of the Magnificat (Botticelli), 87 Madonna of the People (Barocci), 194 Madonna of the Pomegranate (Botticelli), 86

Madonna of the Snow (Reni), Madonna with the Long Neck (Parmigianino), 177 Maestà (Rucellai Madonna) (Duccio), 29 Maestà (Madonna Enthroned) with Angels and Four Prophets (Cimabue), 28 Maedalene (Dolci), 224 Magdalene at the Tomb (Savoldo), 137 Magnasco, Alessandro, 232 Magnoli Altarpiece (Madonna and Child with Saints) (D. Veneziano), 56 Manfredi, Bartolomeo, 211 Mannozzi Giovanni (Giovanni da San Giovanni), 212 Mantegna, Andrea, 72-74 Man with a Monkey (A. Carracci), 200 Maria Theresa of Vallabrioa on Horseback (Goya), 311 Marie-Adelaide of France in Turkish Dress (Liotard), 303 Market at Haarlem. The (Berckheyde), 256 Marriage at Cana, The (Boscoli), 202 Martini, Simone, 36 Martyrdom of Saint Florian, The (Altdorfer), 287 Martyrdom of Saint Justina, The (Veronese), 189 Masaccio, 52, 53 Masolino da Panicale, 51, 52 Massacre of the Innocents, The (Daniele da Volterra), 179 Master of Hoogstraeten, 267 Master of Saint Cecilia, 35 Master of the San Francesco Bardi, 25, 26

Master of the Virgo inter Virgines, 247 Mazzolino, Ludovico, 130 Mazzucchelli, Pier Francesco (Morazzone), 206 Medusa (Caravaggio), 204 Meliore di Jacopo, 27 Memling, Hans, 259-61 Memmi, Lippo, 36 Michelangelo Buonarroti, 123 Minerva and Arachne (Tintoretto), 186 Morazzone (Pier Francesco Mazzucchelli), 206 Moroni, Giovanni Battista, 191, 192 Moses Defending the Daughters of Jethro (Rosso), 168 Musical Angel (Rosso), 167 Neptune Chasing Coronis (Carpioni), 220 Ognissanti Polyptych (Giovanni da Milano), 42 Orcagna, Andrea, 39 Our Lady of Sorrows (Sassoferrato), 219 Pallas and the Centaur (Botticelli), 92 Pancake Seller (Dou), 252 Panciatichi Holy Family, The (Bronzino), 173 Parmigianino, 176, 177 Perseus and Andromeda (Morazzone), 206 Perseus Liberating Andromeda (Piero di Cosimo), 115 Perugino, 94, 95 Piazzetta, Giovanni Battista. Piero della Francesca, 62-65 Piero di Cosimo, 115 Pietà (Giottino), 40

Pietà (Lorenzo da

Sanseverino), 120 Pietà (Perugino), 94 Pilate Shows Christ to the People (Beuckelaer), 266 Pippo Spano (Castagno), 66 Pisan School, 24 Poet Casio, The (Boltraffio). Pollaiolo, Antonio, 76-78, 81 Pollaiolo, Piero, 79-81 Polyptych of Saint Pancras (Daddi), 37 Pontormo, 161-65 Pope Leo X with Cardinals Giulio de' Medici and Luigi de' Rossi (Raphael), 141 Portinari Altarpiece (Goes), 262-64 Portrait of a Cardinal (Mantegna), 73 Portrait of a Courtesan (Forabosco), 218 Portrait of a Magistrate (A. Longhi), 241 Portrait of an Old Man (Rembrandt), 251 Portrait of an Unknown Man (Cleve), 268 Portrait of an Unknown Man (Memling), 261 Portrait of an Unknown Man (Francesco Maria della Rovere?) (Raphael), 139 Portrait of an Unknown Woman (Cleve), 269 Portrait of a Woman (Bugiardini), 126 Portrait of a Woman (Piombo), 144 Portrait of a Young Man with Gloves (Franciabigio), 146 Portrait of a Young Man with a Medal (Botticelli), 84

Portrait of a Young Woman (A. Pollaiolo), 78 Portrait of the Artist's Father (Campi), 169 Portrait of the Artist's Father (Dürer), 279 Portrait of the Sick Man (Titian), 152 Port with Villa Medici (Claude), 297 Presentation in the Temple. The (A. Lorenzetti), 34 Preti, Mattia, 221 Primavera (Botticelli), 88. Rape of Europa, The (Ferretti), 235 Rape of Ganymede, The (Gabbiani), 229 Raphael, 138-43 Recco, Giuseppe, 228 Rembrandt van Rijn, 250, Reni, Guido, 207, 208 Rest on the Flight into Egypt, The (Correggio), 154 Rest on the Flight into Egypt, The (Dosso Dossi), 157 Resurrection of Lazarus, The (Froment), 292 Return of Judith, The (Botticelli), 82 Rinaldo Abandons Armida (Tiepolo), 237 Romano, Giulio, 159 Rosso Fiorentino, 166-68 Rubens, Peter Paul, 270-72 Rucellai Madonna (Maestà) (Duccio), 29 Ruysch, Rachel, 242, 257 Sacrifice of Isaac, The (Allori), 193 Sacrifice of Isaac, The (Caravaggio), 203

Saint Anthony Abbot (Pontormo), 161 Saint Anthony Abbot (Zurbarán), 310 Saint Dominic (Tura), 75 Saint Francis Receiving the Stigmata (Master of the San Francesco Bardi), 26 Saint Ierome (Filippino Lippi), 107 Saint John the Evangelist and Stories from His Life (Biondo), 41 Saint Matthew and Stories of His Life (Orcagna and Cione), 39 Saint Michael Archangel (Zenale), 10s Saint Philip the Apostle (Dürer), 278 Saint Sebastian (Costa), 113 Saints John the Evangelist and Francis (El Greco), 304, 307 Saints Vincent, James, and Eustace (A. Pollaiolo and P. Pollaiolo), 81 Salome (Berruguete), 306 Salome (Caracciolo), 213 Salvi, Giovanni Battista (Sassoferrato), 219 Salviati, Francesco de' Rossi, 178 Sarto, Andrea del, 147-40 Sassoferrato (Giovanni Battista Salvi), 210 Savoldo, Giovanni Girolamo, 136, 137 Scenes from the Life of Saint Cecilia (Master of Saint Cecilia), 35 Scenes from the Life of Saint Nicholas (A. Lorenzetti), 33 Scenes of the Life of the Blessed Umiltà (P. Lorenzetti), 32

Sebastiano del Piombo, 144. Seghers, Hercules, 249 Self-Portrait (Dolci), 223 Self-Portrait (Liotard), 302 Self-Portrait (Raphael), 138 Self-Portrait (Rubens), 270 Self-Portrait (Sarto), 147 Self-Portrait (Vasari), 180 Self-Portrait (Velázquez), 308 Self-Portrait as a Young Man (Rembrandt), 250 Self-Portrait in Profile (A. Carracci), 199 Sermon of Saint Peter, The (Kulmbach), 289 Signorelli, Luca, 96-98 Sir Richard Southwell (Holbein the Younger). 283 Starnina, Gherardo, 47 Steen, Jan. 254 Still Life (Chimenti), 197 Still Life with Fish (Recco), 228 Still Life with Fruit and Shellfish (Kessel), 255 Summer Diversions (Guercino), 214 Supper at Emmaus, The (Catena), 129 Supper at Emmaus, The (Pontormo), 164 Supper with Lute Player (Honthorst), 248 Susanna and the Elders (Lotto), 132 Susanna and the Elders (Piazzetta), 234 Teniers, David, 273 Thebaid, The (Starnina), 47 Tiepolo, Giovanni Battista, 236, 237 Tintoretto, 185, 186

Titian, 150-53 Transfiguration, The (Savoldo), 136 Triumphal Entry of Henry IV into Paris (Rubens), 272 Tura, Cosmè, 75 Uccello, Paolo, 54-55 Vanity (Preti), 221 Vasari, Giorgio, 180-82 Vecchietta (Lorenzo di Pietro), 61 Vecchio, Palma, 134, 135 Velázquez, Diego, 308, 309 Veneziano, Domenico, 56 Veneziano, Paolo, 48, 49 Venus (Credi), 110 Venus of Urbino, The (Titian), Venus with Satyr and Cupids (A. Carracci), 201 Veronese, Paolo, 187-90 Verrocchio, Andrea, 102 View of the Uffizi (Zocchi), Visitation, The (Albertinelli). Vouet, Simon, 295, 296 Vulcan's Force (Vasari), 182 Warriors and Old Men (Carpaccio), 119 Warrior with Shield Bearer (Giorgione), 128 Water Carrier of Seville, The (Velázquez), 300 Wevden, Roger van der, Witchcraft (Dosso Dossi). Young Bacchus (Caravaggio), Zenale, Bernardino, 105 Zocchi, Giuseppe, 6 Zucchi, Iacopo, 196 Zurbarán, Francisco de, 310

Editor: Abigail Asher

Series Design: Patrick Seymour

Production Manager: Matthew Pimm

Photograph on page 92: Raffaello Bencini, Florence.

All other photographs by Paolo Tosi, Summerfield Press Limited, Bagno a Ripoli (Florence), except those on the following pages, which are by Takashi Okamura: front and back cover, 28, 29, 35, 37–39, 42–45, 57, 59, 60, 66–69, 78, 79, 82, 84, 85, 88–91, 123, 163, 164, 172, 178, 196.

Text and compilation, including selection, placement, and order of text and images, copyright © 1994 Abbeville Press. All rights reserved under international copyright conventions. No part of this book may be reproduced or utilized in any form or by any means, electronic or mechanical, including photocopying, recording, or by any information storage and retrieval system, without permission in writing from the publisher. Inquiries should be addressed to Abbeville Publishing Group, 22 Cortlandt Street, New York, N.Y. 10007. The text of this book was set in Bembo. Printed and bound in China.

First hardcover edition

15 14 13 12 11 10 9 8 7 6 5 4 3 2 1

The Library of Congress has cataloged the paperback edition as follows:

Treasures of the Uffizi

p. cm.

Includes index.

ISBN 1-55859-559-7

Painting—Italy—Florence—Catalogs.
 Galleria degli Uffizi—Catalogs.
 Title.

N2570.A54 1994

759.94'074'455I—dc20

93-36611

Hardcover ISBN 0-7892-0575-0

SELECTED TINY FOLIOS™ FROM ABBEVILLE PRESS

- American Art of the 20th Century: Treasures of the Whitney Museum of American Art 0-7892-0263-8 . \$11.95
- American Impressionism 0-7892-0612-9 \$11.95
- Paul Cézanne 0-7892-0124-0 \$11.95
- Edgar Degas 0-7892-0201-8 \$11.95
- The Great Book of French Impressionism 0-7892-0405-3 \$11.95
- Treasures of British Art: Tate Gallery 0-7892-0541-6 \$11.95
- Treasures of Folk Art 1-55859-560-0 \$11.95
- Treasures of Impressionism and Post-Impressionism:
 National Gallery of Art 0-7892-0491-6 \$11.95
- Treasures of the Hermitage 0-7892-0104-6 \$11.95
- Treasures of the Louvre 0-7892-0406-1 \$11.95
- Treasures of the Musée d'Orsay 0-7892-0408-8 \$11.95
- Treasures of the Musée Picasso 0-7892-0576-9 \$11.95
- Treasures of the Museum of Fine Arts, Boston 0-7892-0506-8 ■ \$11.95
- Treasures of the National Gallery, London 0-7892-0482-7 \$11.95
- Treasures of the National Museum of the American Indian 0-7892-0105-4 • \$11.95
- Treasures of 19th- and 20th-Century Painting:
 The Art Institute of Chicago 0-7892-0402-9 \$11.95
- Treasures of the Prado 0-7892-0490-8 \$11.95
- Treasures of the Uffizi 0-7892-0575-0 \$11.95
- Women Artists: The National Museum of Women in the Arts 0-7892-0411-8 • \$11.95